Huntsville

IN VINTAGE POSTCARDS

D1257554

POSTCARD HISTORY SERIES

Huntsville

IN VINTAGE POSTCARDS

Alan C. Wright

ARCADIA
PUBLISHING

Published by Arcadia Publishing
Charleston, South Carolina

Printed in the United States of America

Library of Congress Catalog Card Number: 00-100773

For all general information contact Arcadia Publishing at:
Telephone 843-853-2070
Fax 843-853-0044
E-mail sales@arcadiapublishing.com
For customer service and orders:
Toll-Free 1-888-313-2665

Visit us on the Internet at www.arcadiapublishing.com

CONTENTS

Introduction 7

1. Greetings 9

2. The Big Spring 17

3. Courthouse Square 25

4. Businesses and Buildings 33

5. Cotton Mills 49

6. Streets 55

7. Houses 65

8. Schools and Churches 75

9. Hotels and Motels 91

10. General Postcard Views 109

Bibliography 127

Acknowledgments 128

In memory of Mom, Helen Archer Wright.

To my wife Tracy, thanks for your unwavering support of this project and my many hobbies.

INTRODUCTION

Huntsville was founded in 1805 when John Hunt, for whom the city is named, came to what is now Madison County and built his two-room log cabin above the "Big Spring." Robert Williams, governor of the Mississippi Territory, created Madison County by proclamation on December 13, 1808. Provision was made by the federal government to have land sold at public auction beginning on August 7, 1809. Huntsville owes much of its early growth to Georgia planter Leroy Pope, who built his mansion atop Echols Hill *c*. 1814. During the land auctions of August 1809 he purchased the land around Big Spring for $23.50 an acre. Later he sold the town most of its property while donating some too. On December 23, 1809, commissioners were given authority by the Mississippi Territory Legislature to select a county seat for Madison County. In 1810 Leroy Pope and associates laid out the town, which contained about 60 acres. At the suggestion of Pope, the official town name was designated as "Twickenham." The name was changed to Huntsville on November 25, 1811, by act of the territorial legislature in honor of its first settler. The first lot was sold July 5, 1810, and by 1811 the influx of people into the area was so rapid that the public land office was moved from Nashville to Huntsville. Huntsville is a city of many firsts. In the early 1800s Huntsville would become the first English-speaking community in what would soon become the state of Alabama. The city was incorporated in 1811 and was chosen as the county seat, where it became the home of the state's first bank, public library, public water supply, protestant church, and Masonic Lodge. But the city's most prestigious honor was being named the first capital of Alabama. In 1819, Huntsville was home of the constitutional convention that actually formed the state of Alabama. From 1819 to the late 1890s Huntsville, like the rest of the young and expanding nation, saw and participated in the continued growth of governmental services, business enterprises, and social activities.

The first picture postcard in the United States appeared in 1893 as part of the Chicago's World Colombian Exposition. Postcards were quick to catch on, and the first part of the 20th century was the Golden Age of Postcards. Not only did postcards visually capture the diversity of our nation, but they provided an easy way to communicate with friends, relatives, and loved ones.

This selection of postcards, most of them published before 1940, illustrates the many facets of life in Huntsville. The balance of the cards, published in the 1940s and later, round out this snapshot story of Huntsville. The story is of course incomplete because of us being limited to the images preserved on postcards. For example, no postcards are known to exist of the *c.* 1860s railroad depot. This was highly unusual, as train depots are generally a very commonly depicted site in postcards, regardless of the size of town.

One

GREETINGS

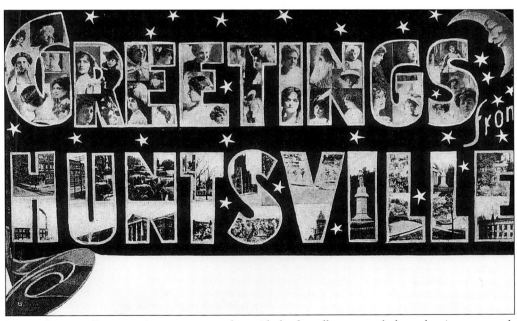

Postcards extending greetings were popular with both collectors and those buying postcards to send. Some of these cards were customized for individual cities with a potpourri of views. (Courtesy of George and Peg Heeschen.)

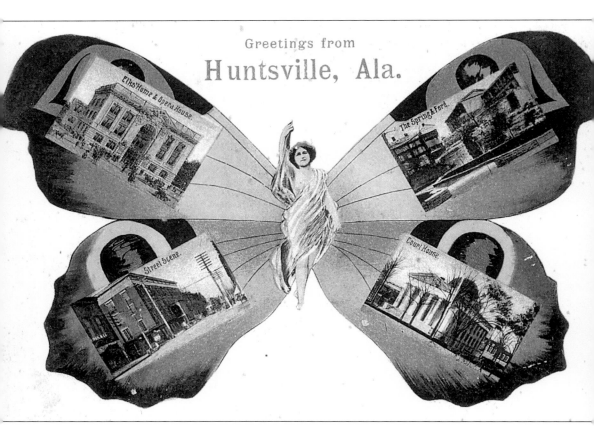

Greetings from
Huntsville, Ala.

These "Greetings from Huntsville, ALA" cards depict views of some of Huntsville's prominent landmarks: top left, Elk's home and opera house; top right, the Spring & Ford; bottom left, a street scene of Jefferson Street and the Huntsville Hotel; and bottom right, the second courthouse. (Courtesy of George and Peg Heeschen.)

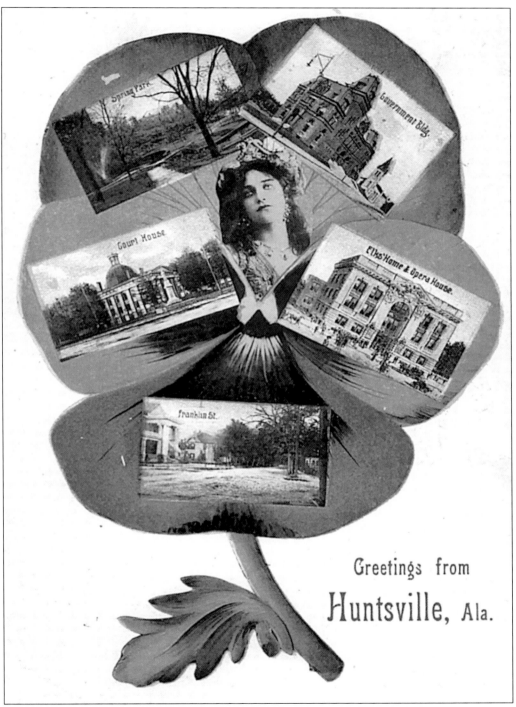

More views in this "Greetings From" series include Big Spring Park, top left; a government building (the federal courthouse and post office), top right; the second courthouse, middle left; Elk's home and opera house, middle right; and a view of Franklin Street, bottom center.

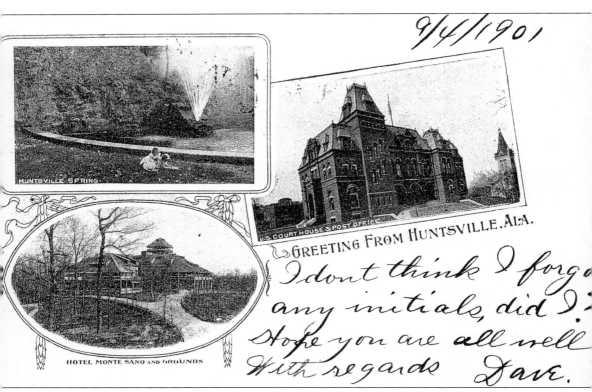

9/4/1901

HUNTSVILLE SPRING

U.S. COURT HOUSE & POST OFFICE

GREETING FROM HUNTSVILLE, ALA.

HOTEL MONTE SANO AND GROUNDS

I dont think I forg[o]
any initials, did I.
Hope you are all well
With regards Dave.

More southern hospitality and "Greetings from Huntsville, ALA" cards are included on this page starting at top left with the Huntsville Spring (notice the young child and dog in the foreground); top right, a government building; and bottom left, the Hotel Monte Sano and grounds. The 200-room Hotel Monte Sano was built in 1887 and torn down in 1944. (Courtesy of George and Peg Heeschen.)

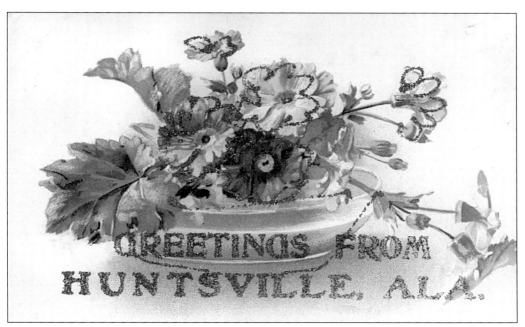

To customize many of the "Greetings From" postcards of the day, including this one, the appropriate message was written on the card with an adhesive material and sprinkled with glitter. This postcard is postmarked March 11, 1908.

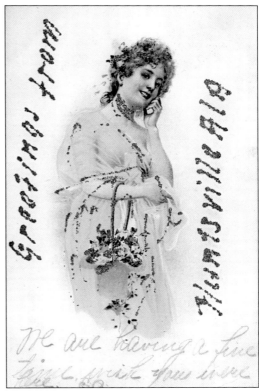

This "Greetings from Huntsville, ALA" card is postmarked, Normal, ALA, 11 a.m. October 5, 1906, and was received in Florence, ALA, 3 p.m. October 5, 1906. Mail service in the early days could be fast and reliable if the regularly scheduled and frequently running railroads were involved in the shipment. The handwritten note says, "We are having a fine time, wish you were here. EO."

As the years pass, the "Greetings From" postcards show the growth and changes of the city from a farming and mill town to the space capital.

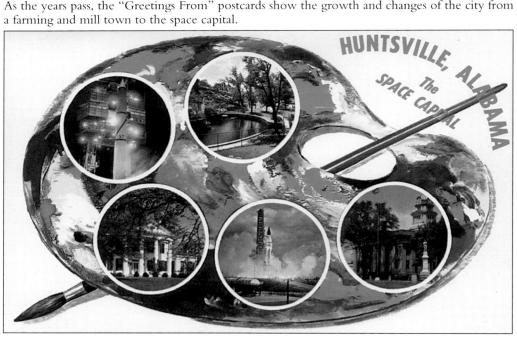

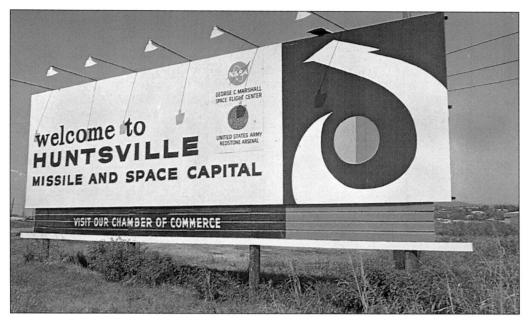

With the continued growth of the city, to include improved highways, billboards were erected to further extend welcomes to Huntsville. The "Space Capital of the Universe" was our claim to fame and greeting to our arriving visitors, residents, and passing-through travelers.

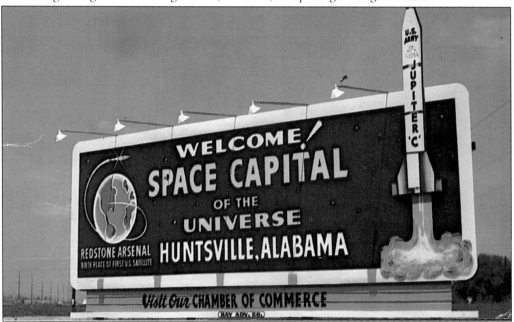

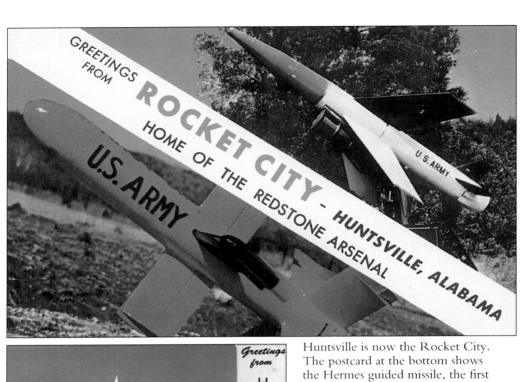

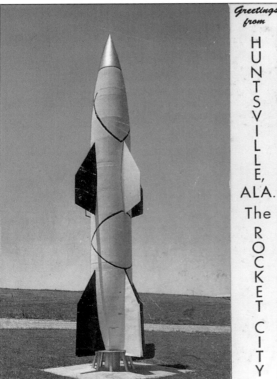

Huntsville is now the Rocket City. The postcard at the bottom shows the Hermes guided missile, the first American-made guided missile, put on public display at Redstone Arsenal, May 14, 1953. This missile now stands at the southwest corner of Airport Road and Memorial Parkway.

Two

THE BIG SPRING

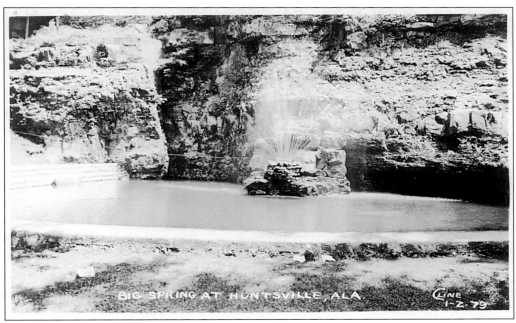

BIG SPRING AT HUNTSVILLE, ALA.

The Big Spring, located in downtown Huntsville just west of the courthouse square, has been a focal point of the town since John Hunt settled near the spring in 1805. The Spring's 24 million-gallon flow provided the main water source for early residents of Huntsville. The fountain was added later.

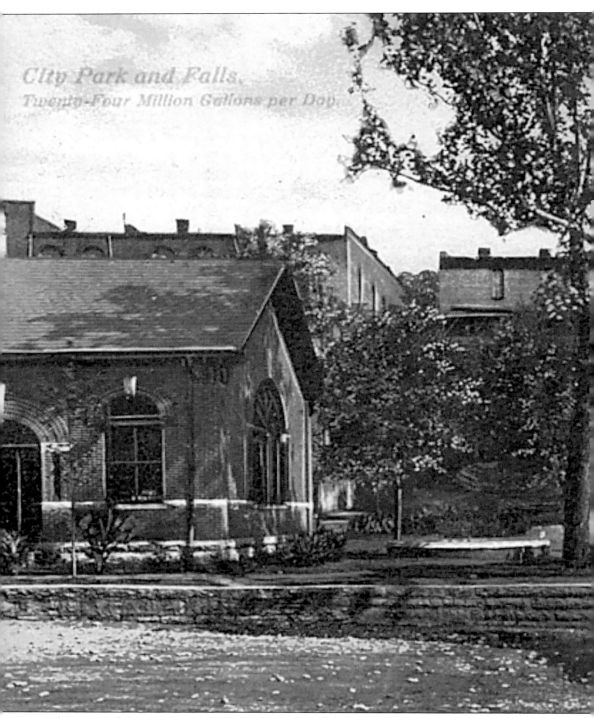

City Park and Falls.
Twenty-Four Million Gallons per Day.

This view of the Big Spring basin in the early 1900s (postcard postmarked July 1912) shows the dam, part of the water works building to the left, and the buildings of cotton row in the background. Cotton row was located on the west side of the courthouse square and included

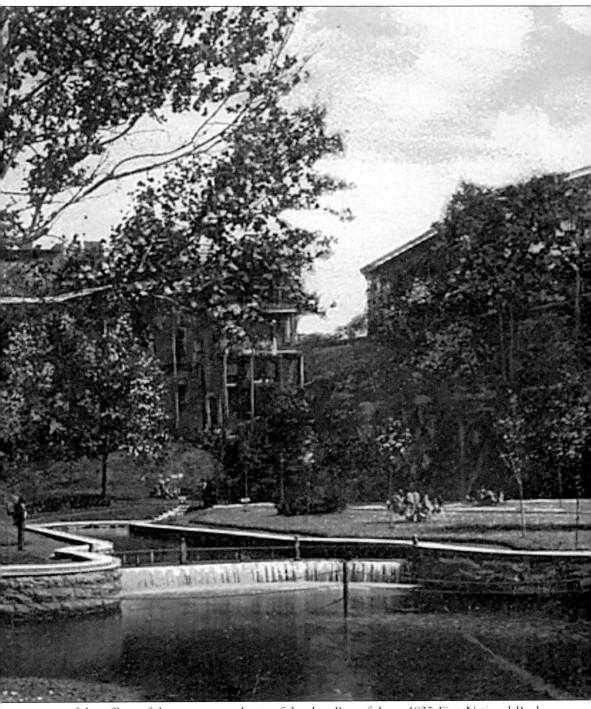

many of the offices of the cotton merchants of the day. Part of the *c.* 1835 First National Bank Building can be seen in the top right. (Courtesy of George and Peg Heeschen.)

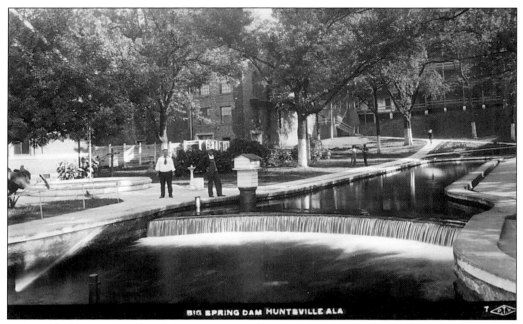

Early real-photo postcards of the Big Spring show panoramic views of the dam and the daily social activities that were common around the Big Spring.

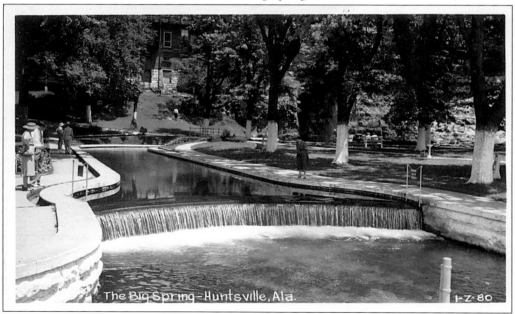

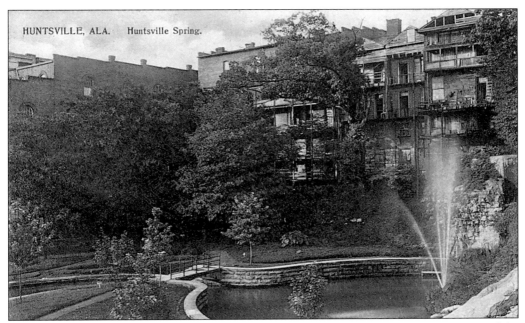

HUNTSVILLE, ALA. Huntsville Spring.

The fountain of the Big Spring is pictured here with the rear of the cotton row buildings of the west side square. These buildings were torn down during the 1960s to facilitate urban renewal, and the area is now an upper-level viewing area for the Big Spring. These views are *c.* 1908–1912.

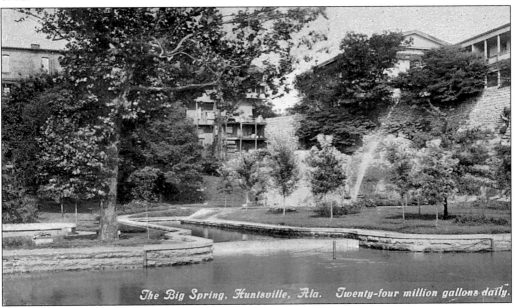

The Big Spring, Huntsville, Ala. Twenty-four million gallons daily.

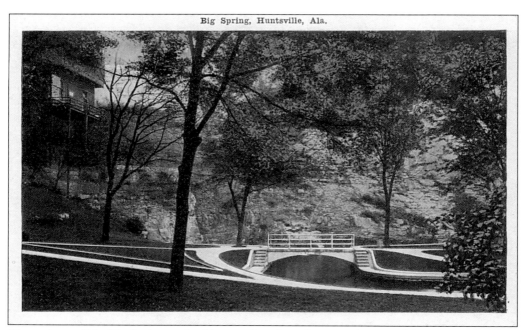

These views of the Big Spring are looking south and southwest with parts of the west side square's cotton row buildings being visible in the top view. The bottom view shows buildings that were located where the present-day Huntsville municipal building is located.

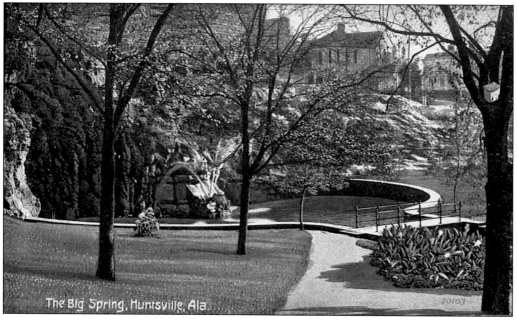

The Big Spring, Huntsville, Ala.

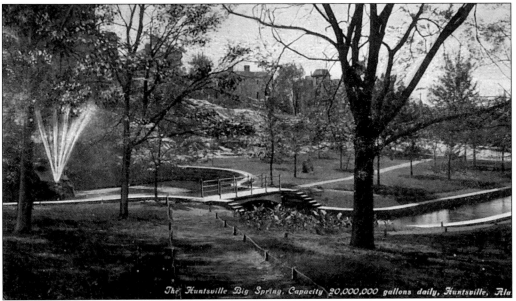

The Huntsville Big Spring, Capacity 20,000,000 gallons daily, Huntsville, Ala

If this same southwesterly view of the Big Spring was taken today, we would see that the Huntsville Museum of Art and Huntsville Municipal Building would be located in the background.

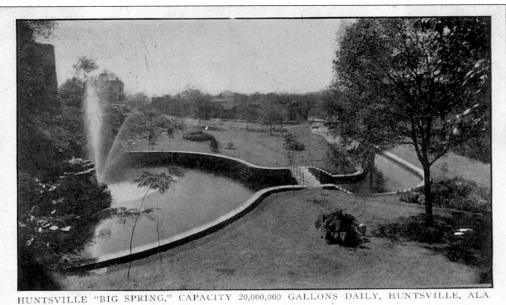

HUNTSVILLE "BIG SPRING," CAPACITY 20,000,000 GALLONS DAILY, HUNTSVILLE, ALA.

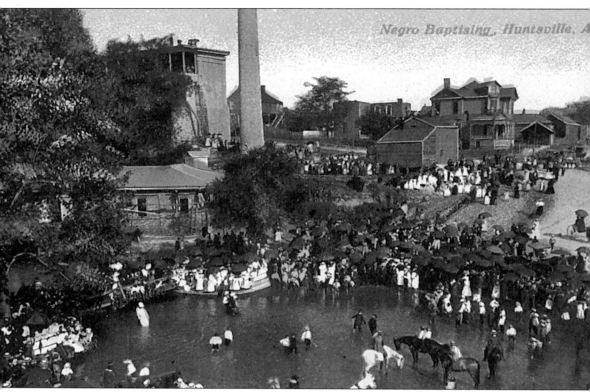

The Big Spring, in addition to being the city's water works, which can partially be seen in the back left of this view, was the site of many public and social gatherings of the day, including this *c.* 1895 "negro baptizing" of St. Bartley Primitive Baptist Church.

Three

COURTHOUSE SQUARE

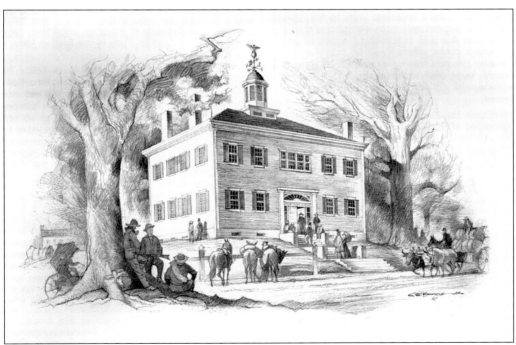

There are no known photographs of Madison County's courthouse, which was built in 1811, three years after the county was created by proclamation of Governor Robert Williams of the Mississippi Territory. The first courthouse was the most short lived of the four to date, being torn down in 1837. (Sketch courtesy of C.E. Monroe Jr.)

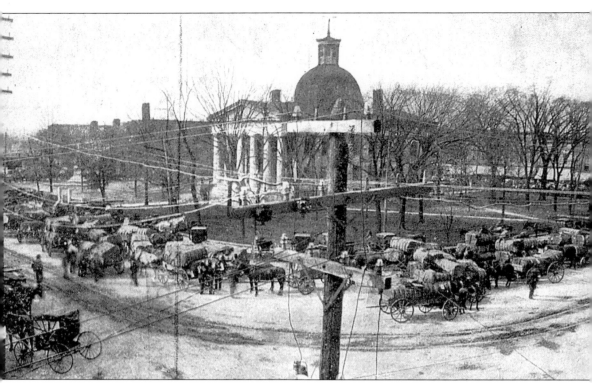

This is a c. 1912 panoramic view of the second Madison County Courthouse and Square. While telegraph, telephone, and electric lines are seen in abundance, the automobile has yet to become a fixture on the square or as a vehicle to transport the county's biggest crop—cotton—from fields to the market. (Courtesy of George and Peg Heeschen.)

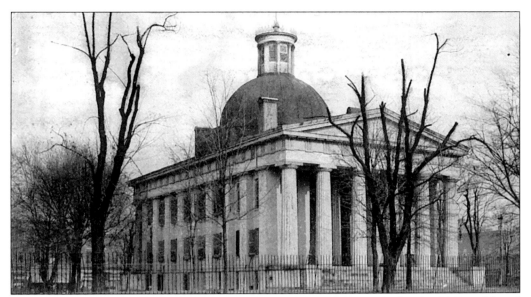

The second Madison County Courthouse was built during the period of 1837–1840 and lasted longer than its predecessor or its replacement, 1840–1913. This view is *c.* 1906.

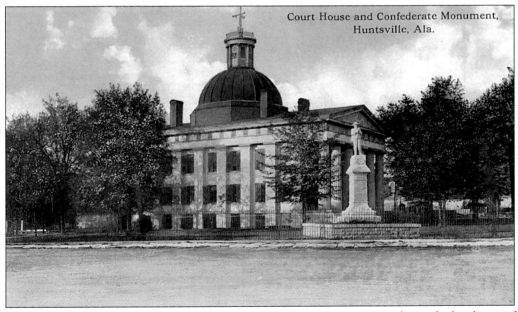

Designed by architect George Steele, the second Madison County Courthouse had a dome of copper. The Confederate monument, which was erected in 1905, is in the foreground.

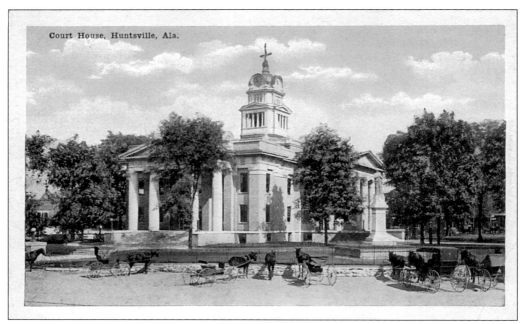

Similar to the view of the courthouse and square on the bottom of page 27, this card pictures the third courthouse with the Confederate monument in the same foreground location. The courthouse was built in 1913–1914 and was in use from 1914 to 1963.

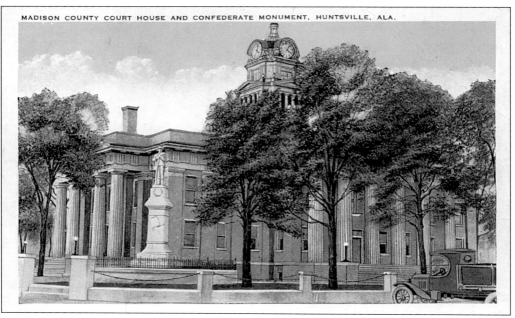

MADISON COUNTY COURT HOUSE AND CONFEDERATE MONUMENT, HUNTSVILLE, ALA.

As time passes, the trees grow, the courthouse square fencing changes, and the automobile appears.

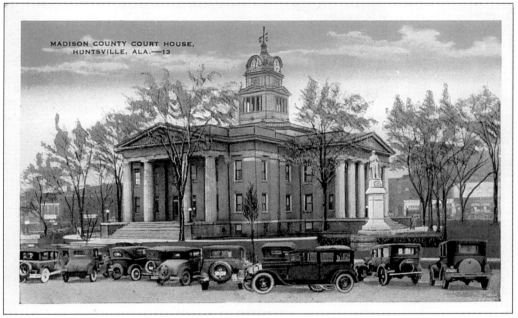

The Confederate monument is in the same foreground location, only now automobiles have become fixtures on the square.

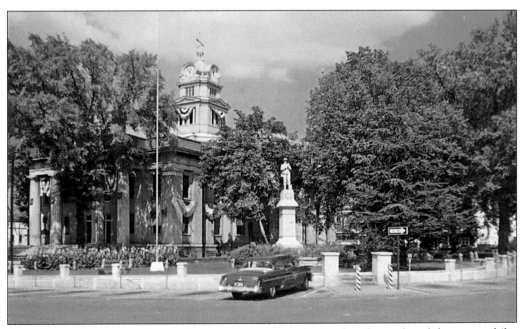

Here the trees have grown larger, the courthouse square fencing has changed, and the automobiles are more recent. This view also shows the courthouse with patriotic bunting.

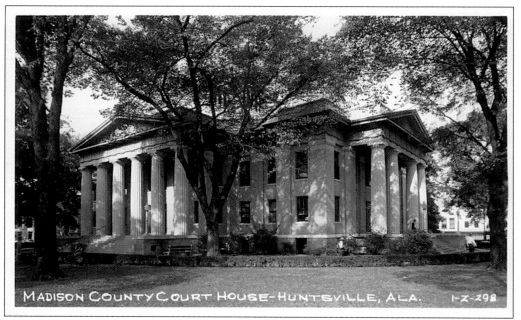

MADISON COUNTY COURT HOUSE-HUNTSVILLE, ALA. 1-Z-298

The third Madison County Courthouse was designed by architect C.K Colley and built 1913–1914. A shady view late in the structure's existence highlights its use of massive doric columns carried forward from the design of the second courthouse to placate the feelings of those who wanted it remodeled instead of being replaced. The third courthouse was torn down in 1967 to make way for a "modern" structure . . . if only we would have known what preservation was then.

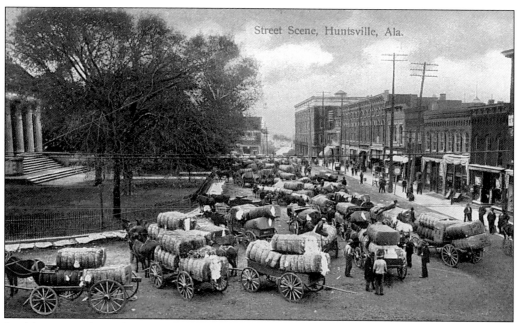

Street Scene, Huntsville, Ala.

Looking west along the north side of the courthouse square we see cotton at market. The Huntsville Hotel can be seen at the end of the street.

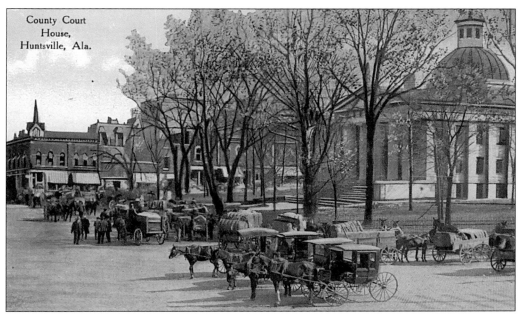

County Court
House,
Huntsville, Ala.

A Saturday afternoon on the square included the cotton crop coming to market during the harvest season. Many of the cotton brokers had offices on the square and prices were negotiated on the street. These two similar views are looking east, with the second courthouse, east side square, and the steeple of the Randolph Street Church of Christ in the background.

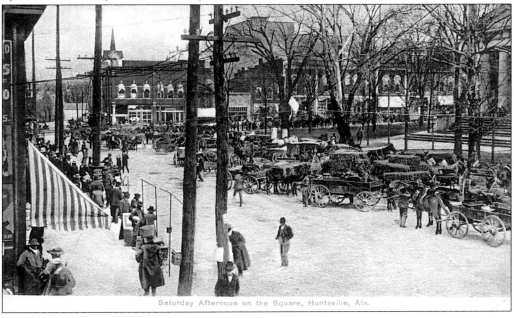

Saturday Afternoon on the Square, Huntsville, Ala.

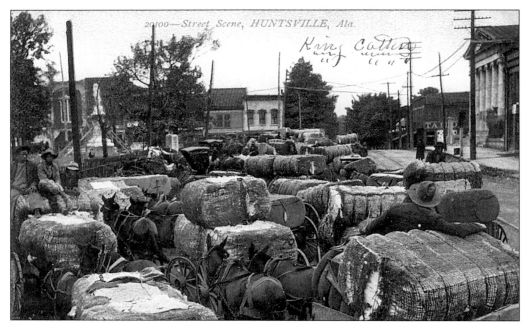

King Cotton

This view looking south toward Madison Street along the west side square and cotton row shows part of the area's cotton crop coming to market *c.* 1905. Note the handwritten message "King Cotton" in the upper right-hand corner.

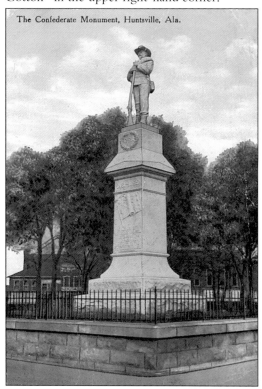

The Confederate Monument, Huntsville, Ala.

The Confederate monument, a memorial to the Confederate dead, was placed on the west lawn of the courthouse by the United Daughters of the Confederacy in 1905.

Four

BUSINESSES AND BUILDINGS

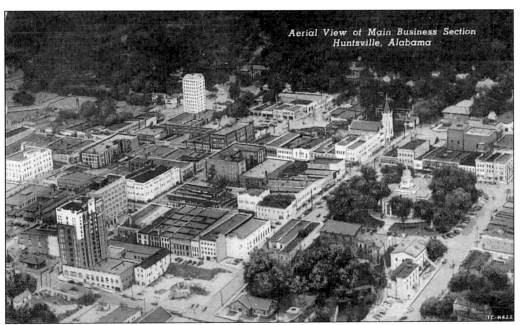

Aerial View of Main Business Section
Huntsville, Alabama

This early 1950s aerial view of Huntsville's main business section shows just how large and dense downtown Huntsville was prior to urban renewal and suburban flight. The Huntsville Daily Times building can be seen in the upper left-hand corner, the federal courthouse and post office is visible to the left, the Russell Erskine Hotel is in the lower left corner, and the Madison County Courthouse is visible in the center right side.

This card dated June 18, 1907, by its sender shows some of the many views of Huntsville. Clockwise from top right, Negro Baptizing; The Big Spring; Elks Home and Opera House; Big Spring Park looking southwest; looking south toward Madison Street along the west side square and cotton row; the Big Spring and dam; the second Madison County Courthouse; Merrimack Mills; Carnegie Library, Normal, AL; African Americans picking cotton; and the Confederate monument.

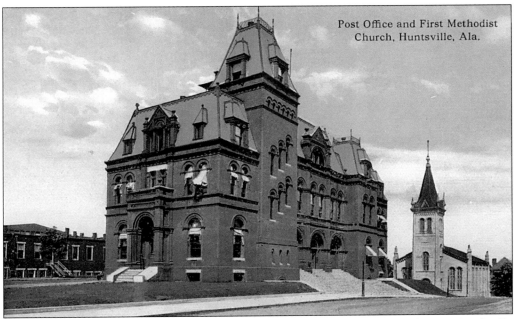

Post Office and First Methodist
Church, Huntsville, Ala.

This view looking northwest is of the federal courthouse and post office with the First Methodist Church in the background. This building was built 1888–1890 and was razed in 1954 for and still is in use as a surface parking lot at the northwest corner of Eustis Avenue and Greene Street.

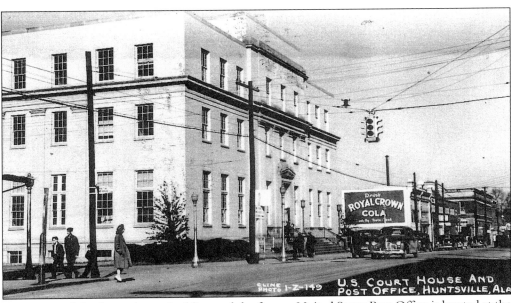

The current federal courthouse building and the former United States Post Office is located at the northeast corner of Holmes Avenue and Jefferson Street. This view is *c.* 1940. (Courtesy of the Huntsville-Madison County Public Library.)

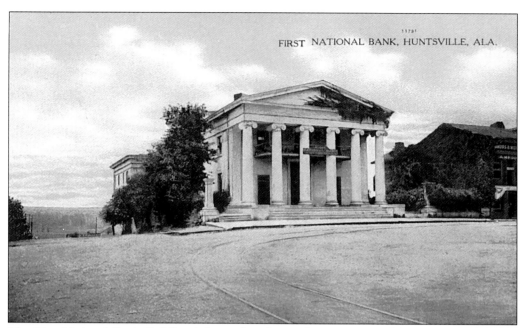

The First National Bank Building is located at the southwest corner of the courthouse square. The last of the original buildings of early Huntsville on the public square, this Greek Revival structure by architect George Steele was built in 1835 and has been in continuous operation as a financial institution since it was built.

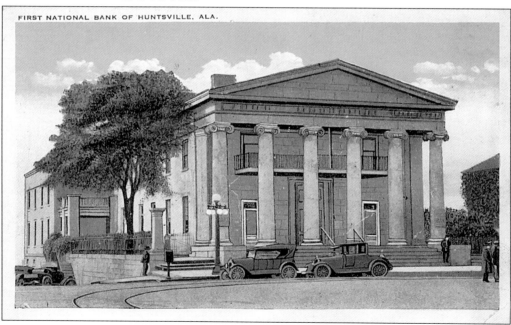

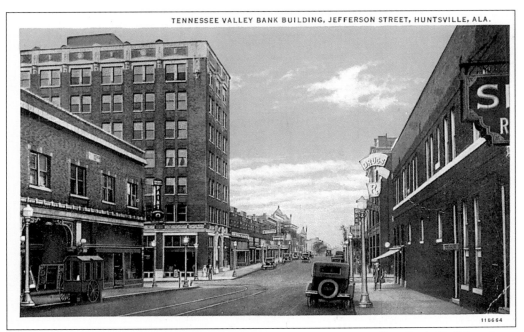

This view of Jefferson Street looking north shows the Tennessee Valley Bank Building (now known as the Terry-Hutchens building) at the northwest corner of Jefferson Street and Clinton Avenue. The tracks of Huntsville's long removed transit system can be seen in the foreground.

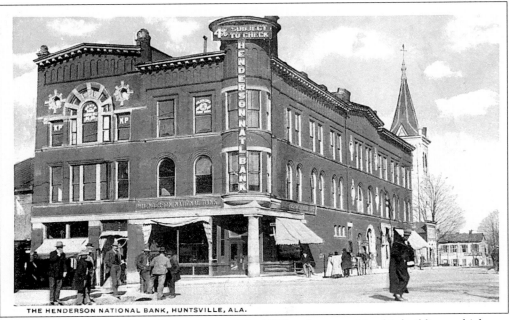

THE HENDERSON NATIONAL BANK, HUNTSVILLE, ALA.

The Henderson National Bank was chartered in 1907 and operated in this building, which was located at the northeast corner of Randolph Avenue and Washington Street until 1948, when it moved to the northwest corner of Spring Avenue and Jefferson Street.

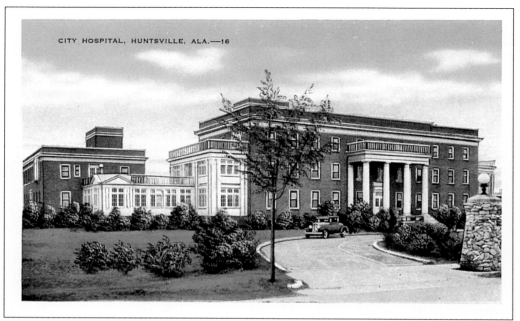

These views show the new and modern Huntsville Hospital built in 1926 to replace a large two-story structure donated to the city in 1904. Located at the northwest corner of Madison Street and Fifth Avenue (now Governors Drive), this building was demolished in 1982 to accommodate expansion for the current hospital.

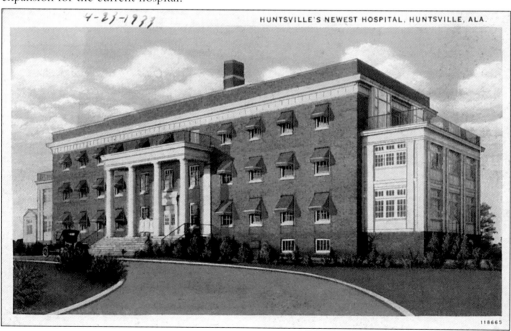

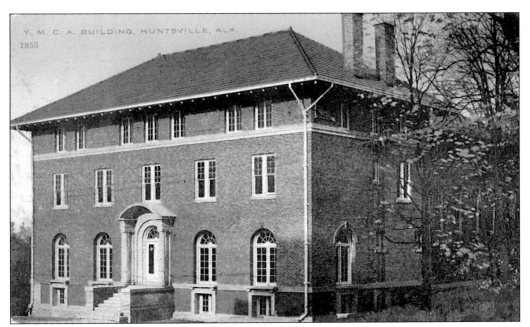

W.S. Frost came to Huntsville in 1909 for the purpose of organizing the Huntsville branch of the Young Men's Christian Association. Land for the building was purchased in 1910 and on February 1, 1912, the YMCA building, which was designed by local architect Edgar L. Love, was ready for occupancy.

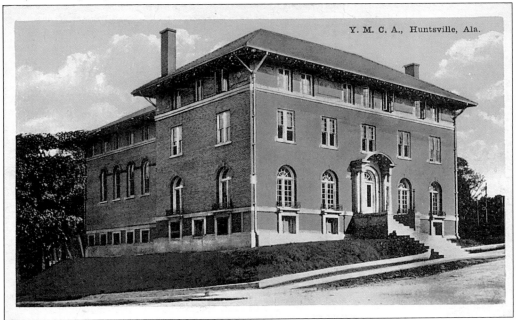

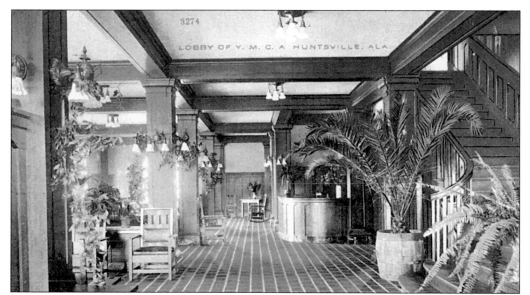

This is the spacious interior of the 1912 Huntsville, ALA, YMCA building. The YMCA was in use of this building until 1998; it is now under renovation for law offices. It is located at the southeast corner of Greene Street and Randolph Avenue.

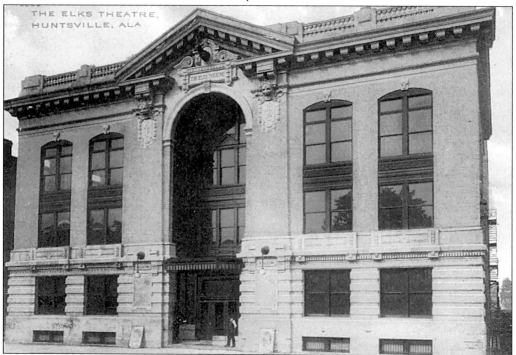

The Elks Theater was built *c.* 1906 by local architect Edgar L. Love and located about mid-block on the north side of Eustis Street between east side square and Green Street. This building was demolished in 1967 and is now a surface parking lot that also includes the land that the federal square and post office was located on.

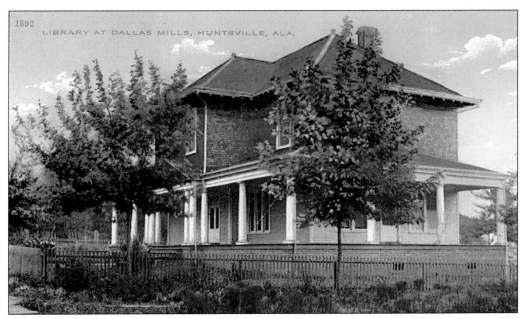

The library at Dallas Mills was one of the many buildings erected by the Dallas Mills, a cotton mill factory and company. It was located along the south side Oakwood Avenue just east of the railroad tracks, at what was the corner of Fourth Street. Like the many cotton mill companies and factory owners of the day, these mills established, sponsored, or donated land and materials for virtual cities and their employees including schools, churches, libraries, and medical facilities.

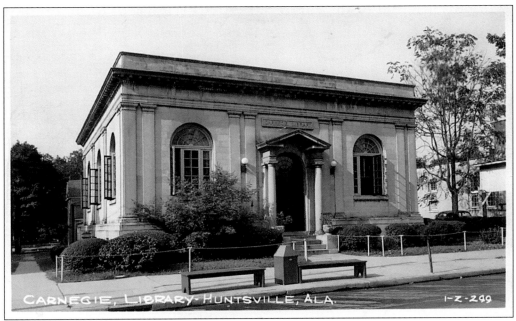

The Carnegie Library was built in 1915 and was also designed by local architect Edgar L. Love. It was located at the northwest corner of Madison Street and Gates Avenue. It was demolished in 1966 to make room for the new municipal building parking lot.

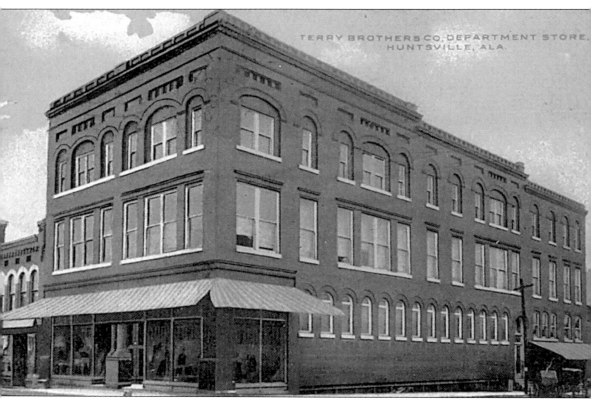
TERRY BROTHERS CO. DEPARTMENT STORE,
HUNTSVILLE, ALA.

The Terry Brothers Company Department Store was erected by Terry Brothers (Tom and S.L.) and Rogers, a local dry goods company, in 1905. Separately, in 1914, P.S. Dunnavant and William Fowler formed a partnership known as Dunnavant and Fowler. In 1916 they were joined by Ira Terry (son of Tom Terry) and the firm became Dunnavant, Fowler, and Terry. After a number of years the partnership with Mr. Fowler and Mr. Terry dissolved and Mr. Dunnavant started a store of his own called "Dunnavant's," which is what this building is known as to most who traded during the 1940s–1960s. The building was renovated in the mid-1980s and is now used as an office building at 100 Washington Street.

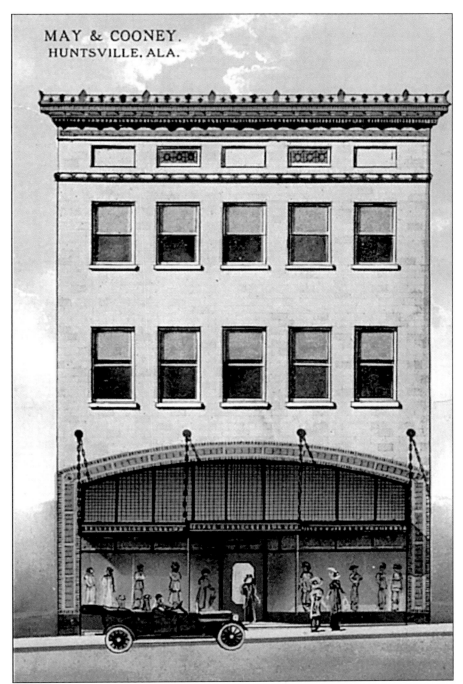

MAY & COONEY.
HUNTSVILLE. ALA.

May & Cooney, a dry goods firm, built this building in 1913. They went bankrupt in 1931 as a result of the Depression. The J.C. Penney store, needing more room from its original 1925 location at 104 Jefferson Street, moved to the May & Cooney building at 3 East Side Square in 1934 and remained there until 1965. The county purchased this building in 1973 for use as a law library.

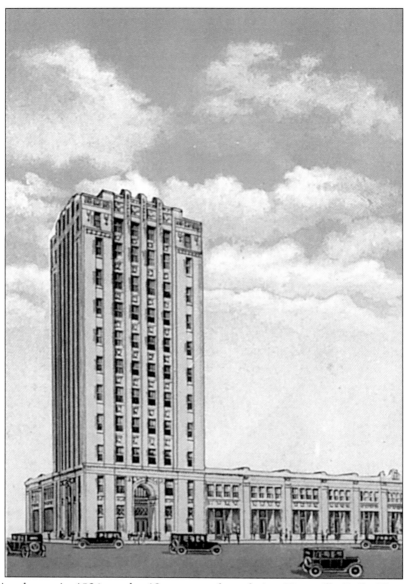

Construction began in 1926 on the 12-story art deco design Huntsville Daily Times building at the southwest corner of Greene Street and Holmes Avenue. It consists of a ten-story tower rising above one corner of a much larger two-story base that contained the newspaper pressroom, offices, and retail space. The building opened in 1928 and served as the newspaper's headquarters until 1956 when it, like many other downtown businesses, moved to the new Memorial Parkway. Originally designed for 11 floors, the 12th floor was added as an afterthought during construction when it was learned that the Russell Erskine Hotel would have 12 floors. As the elevator had already been ordered—it goes only to the 11th floor—the 12th floor is accessed by stairs. Purchased by a local businessman in 1984 with the intention of converting the building into a high-rise condominium complex, plans were halted due to the cost and impracticality of meeting current building codes. The Huntsville Daily Times building, though still standing, remains mostly unused except for the first two floors.

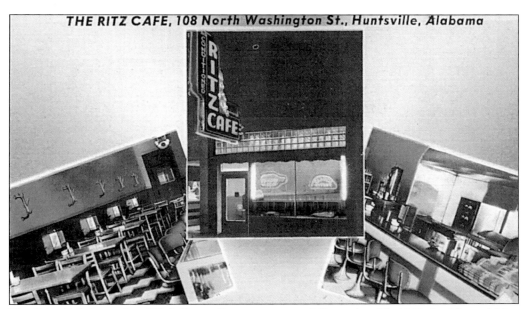

THE RITZ CAFE, 108 North Washington St., Huntsville, Alabama

The Ritz Cafe located at 108 Jefferson Street was opened December 23, 1945, by Mr. and Mrs. Herman Taylor and Mr. and Mrs. R.E. Bennett. The Ritz Cafe was open 7 days a week from 4:30 a.m. to 10:00 p.m. with both counter and table service. For Huntsville's hot summer days the Ritz was "Frigidaire Air Conditioned." (Courtesy of Charles Cataldo Jr.)

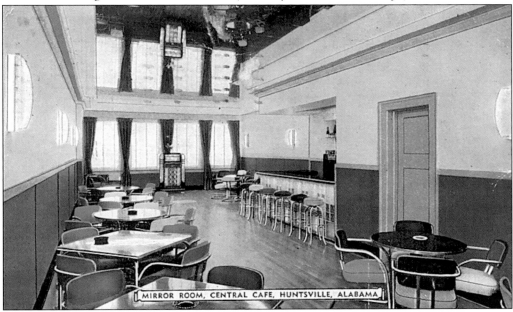

MIRROR ROOM, CENTRAL CAFE, HUNTSVILLE, ALABAMA

The Mirror Room, Central Cafe, opened in 1913 on Jefferson Street and moved to this location at 103 West Clifton Street in 1915. The cafe was purchased by Louis Tumminello in 1928 but not managed by him until 1930. It was placed for sale in 1931 but, after no buyer was found, Mr. Tumminello began remodeling to include the addition of the Mirror Room, "the most modern lounge in the south." At a cost of $12,000, remodeling included plate-glass mirrors, indirect lighting of florescent and neon, air conditioning, and lights in the floor.

45

The U-TEL-IT Restaurant (also known as the BON-AIR Restaurant) was established on May 26, 1951, at 508 Meridian Street by Mr. and Mrs. R.E. Hicks and was in connection with the BON-AIR Motel. The restaurant was operated by Mr. and Mrs. Olan Hicks.

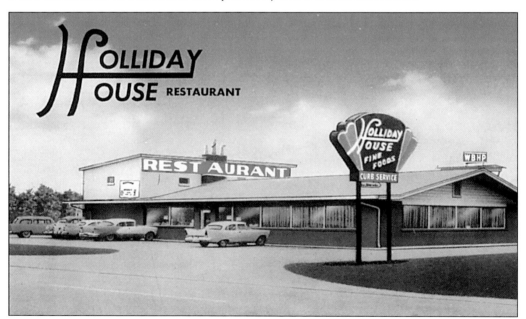

The Holliday House Restaurant, with the WBHP broadcast studio located within, was one of the first businesses opened on the then-new Memorial Parkway (1955). This restaurant later became "Boot's," known for excellent steaks and as the place to go for special occasions. The building was partially demolished in 1999 for use as a used car lot, but the three-flue chimney is still in existence on the remaining two-story structure.

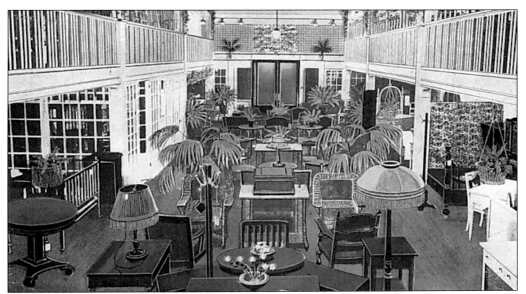

The Mason Furniture Company showing its two-story main showroom is located at 115 E. Clinton Avenue. Founded in 1908 as Manning and Mason, the firm's name was changed to Mason Furniture Company following the death of John Manning in 1908 and the purchase of his interest by James R. Mason. This building was originally built in 1927 to be leased, but it was 1929 before Sears Roebuck signed a contract for it. Minor remodeling was accomplished for the Sears store and they moved in on March 1929; however, Sears withdrew from Huntsville in 1931 as a result of the Depression and Mason's found it necessary to move into the building themselves. They remained until February 1977 when they went out of business. The building is still in use, most recently as an entertainment and dance club. The two-story main showroom and surrounding balconies remain almost unchanged as a dance floor.

The General Finance Company located at 106 W. Clinton Street made personal loans and advertised itself as "a lending institution for working people."

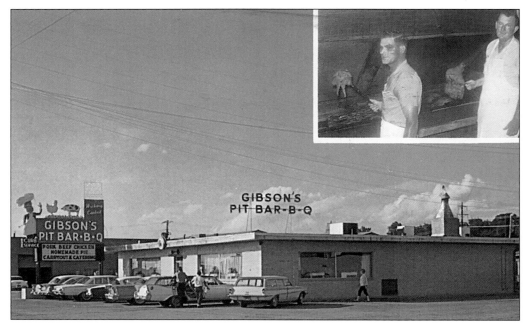

Gibson's Pit Bar-B-Q was located in this building at 3409 S. Memorial Parkway until 1974, when they moved approximately one block north to a new building. Upon Gibson's relocation, ERA Ben Porter Real Estate remodeled and moved into this building.

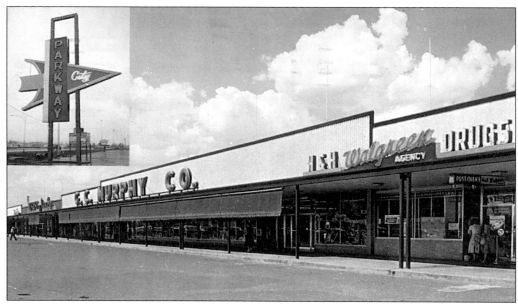

The Parkway Shopping City, also known as Parkway City, was one of the first shopping malls located on the new Memorial Parkway in the late 1950s. Though now an enclosed shopping mall, Parkway City opened as a strip mall with 35 stores, including a G.C. Murphy and H&H Walgreen.

Five

COTTON MILLS

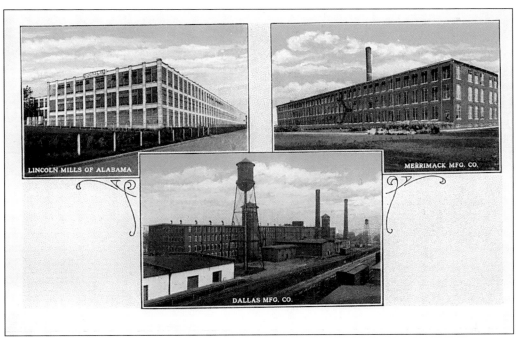

Through the years Huntsville has been home to many cotton mills. Three of the largest are shown here: Lincoln Mills, the Merrimack Manufacturing Company, and the Dallas Manufacturing Company. All three of these mills are now gone, Lincoln and Dallas by fire and Merrimack by the wrecking ball.

COTTON MILL

According to early chamber of commerce publications Huntsville was home to nine cotton mills during one period of the early 1900s, including the following: top left, Huntsville Knitting Mills; top center, unknown; top right Abingdon Cotton Mills, which later became Lincoln Mill; middle

IUNTSVILLE, ALA.

left, Lowe Cotton Mills; center, Dallas Cotton Mill; middle right, West Huntsville Cotton Mills; bottom left, Merrimack Cotton Mills; bottom center, Huntsville Cotton Mills, changed to Margaret Mill; and bottom right, unknown. (Courtesy of George and Peg Heeschen.)

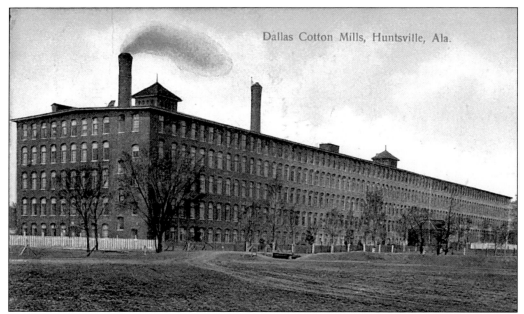

Dallas Cotton Mills, Huntsville, Ala.

Dallas Cotton Mills, opened in 1892, was the biggest and grandest mill in the area and was considered to be one of the finest mills in the South. Due to the large number of Dallas Mills employees, an entire community developed and created what could be called Huntsville's first suburb. The mill was destroyed by fire on July 24, 1991.

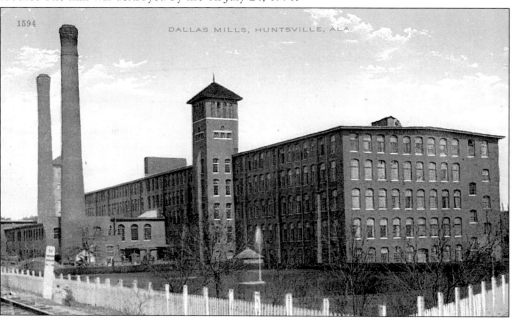

1594 DALLAS MILLS, HUNTSVILLE, ALA.

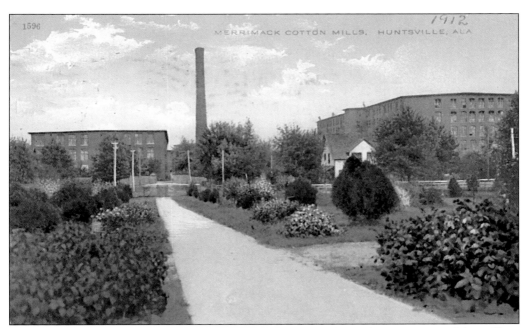

MERRIMACK COTTON MILLS, HUNTSVILLE, ALA.

1912

Construction began on Merrimack Cotton Mills in 1899 with the first operation of the mill on July 9, 1900. Merrimack, like other mills of the day, caused an entire community to be created, including convenient housing for workers it planned to recruit from other towns and outlying areas. A section of this housing can be seen in the bottom right of the view below.

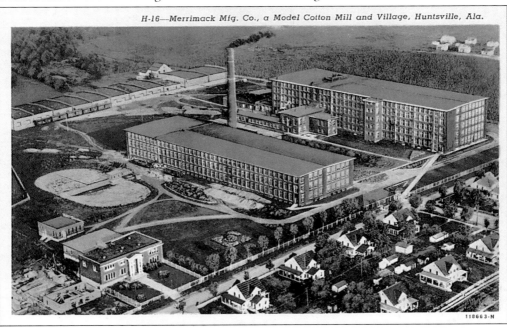

H-16—Merrimack Mfg. Co., a Model Cotton Mill and Village, Huntsville, Ala.

118663-N

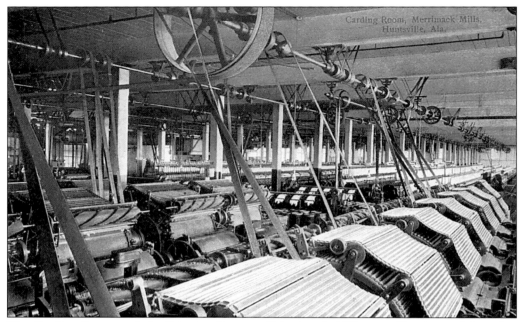

The Carding Room and the Spinning Room of Merrimack Mills were like those of the other mills. Many a Huntsvillain, both adult and child, toiled here from sun-up to sundown.

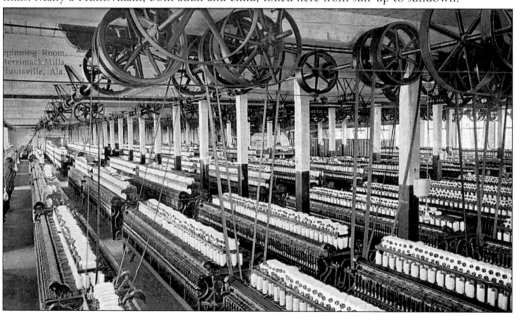

Six

STREETS

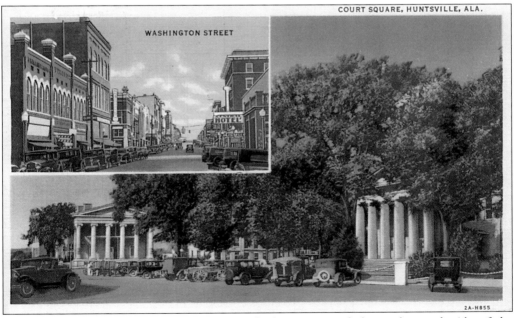

WASHINGTON STREET

COURT SQUARE, HUNTSVILLE, ALA.

This *c.* early 1930s view is of Court Square looking west and shows the south side of the courthouse and the First National Bank building in the background. The inset is of Washington Street looking south with the Dunnavant's building to the middle left.

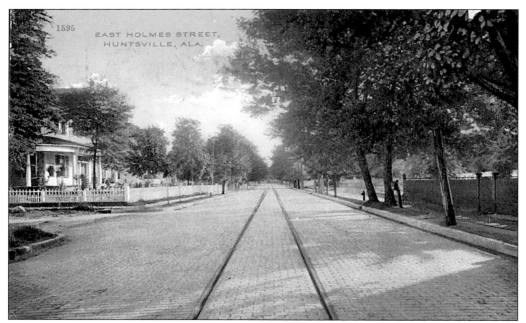

East Holmes Street (now East Holmes Avenue) looking west is pictured in this 1911 postcard during the days when the street was brick-paved and the Huntsville streetcar was in use. The "Sugg Home," which was located at present-day 516 East Holmes Avenue, can be seen to the left.

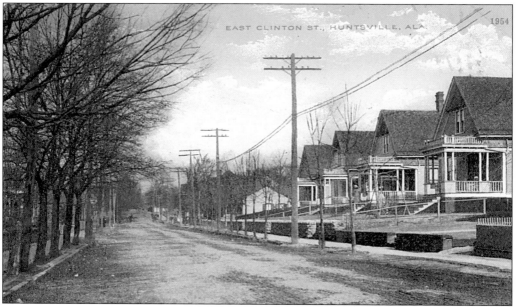

This view of East Clinton Street shows four similar houses of the day along the right side of the street. While the first house is no longer in existence, the other three are still standing at present-day 422, 424, and 426 Clinton Avenue.

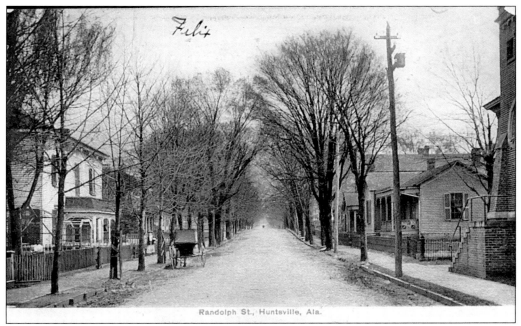

The *c.* 1825 "J.W. Cooper" residence at 405 Randolph Avenue can be seen on the left side of this view with the side steps of the Central Presbyterian Church on the right. The house just behind the church steps is no longer in existence, as the area is now an expansion of the original church building with some parking.

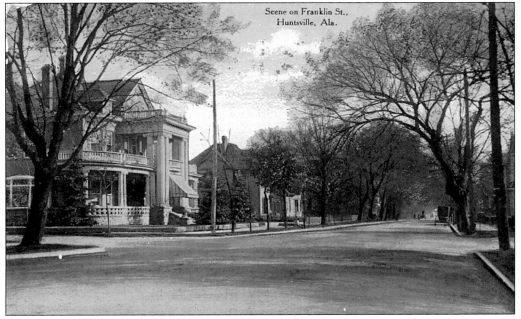

Scene on Franklin St., Huntsville, Ala.

This view of Franklin Street is looking south past the intersection at Williams Avenue. The *c.* 1902 Van Valkenburgh house at 501 Franklin Street can be seen in the left foreground.

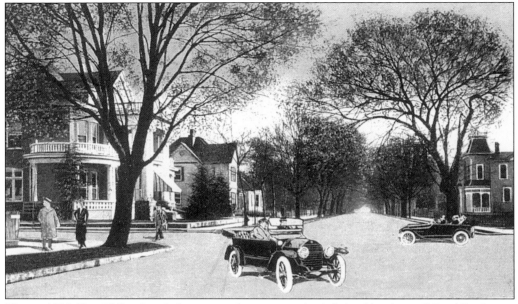

The *c.* 1902 Van Valkenburgh house can be seen to the left in this view of Franklin Street, with the *c.* 1899 "Cooney" house located at 507 Franklin Street visible behind it. The house to the right is still in existence and is presently undergoing renovation. (Courtesy of George and Peg Heeschen.)

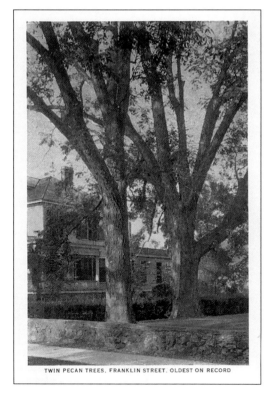

TWIN PECAN TREES, FRANKLIN STREET, OLDEST ON RECORD

The twin pecan trees of Franklin Street were the oldest on record. Now long gone, the trees were most likely located on what is now the lot of 615 Franklin Street. The *c.* 1892 "Betts" house in the foreground is still in existence, located at 607 Franklin Street.

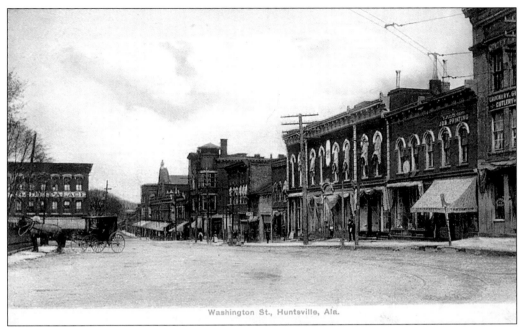

Washington St., Huntsville, Ala.

This early 1900s view of Washington Street is looking north along the East Side Square. The first location of the Henderson National Bank can be seen midway down the street.

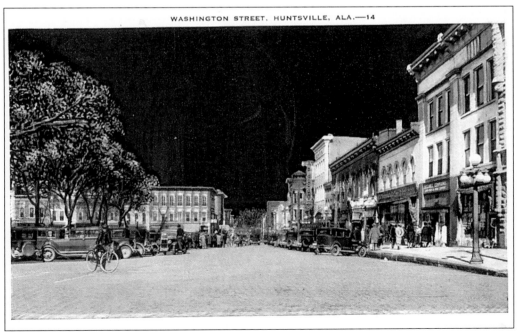

WASHINGTON STREET, HUNTSVILLE, ALA.—14

This is a *c.* 1930s view of Washington Street looking north. The view is almost the same as the one above, but notice the changes—the trolley tracks have been removed, automobiles are more prevalent, and the road appears to be paved with bricks.

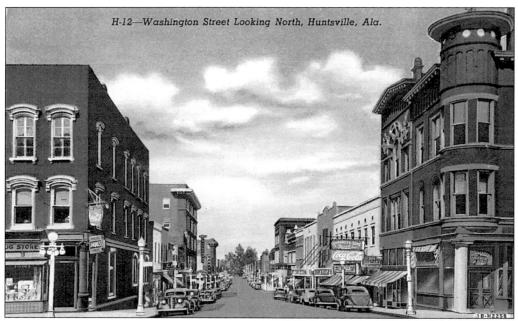

These two views from the 1930s and the 1940s are almost the same east side view of Washington Street. However, time and progress have changed the businesses and signage. Washington Street was one of the main thoroughfares and business districts of the day. (Bottom image, courtesy of the Huntsville-Madison County Public Library.)

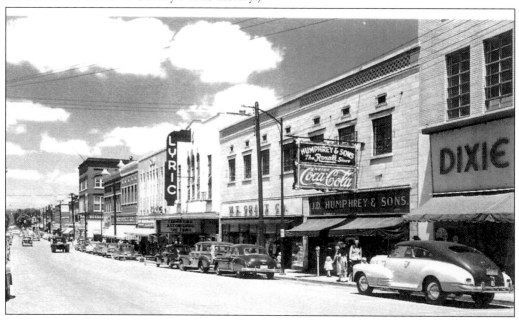

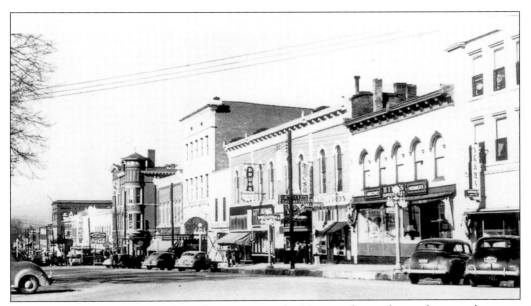

These two late 1940s views of Washington Street looking north are almost the same but note how the Henderson National Bank Building has now been replaced with another building. Also if you look close, you can see that Sears has now become the "11" Grill. (Top image, courtesy of the Huntsville–Madison County Public Library.)

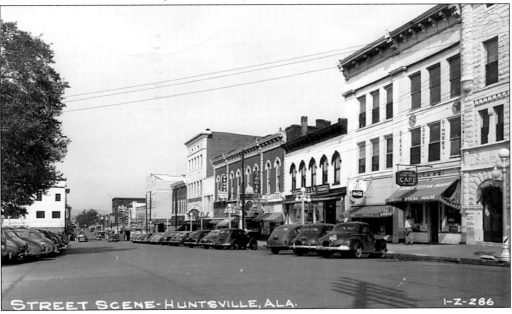

STREET SCENE-HUNTSVILLE, ALA. 1-Z-286

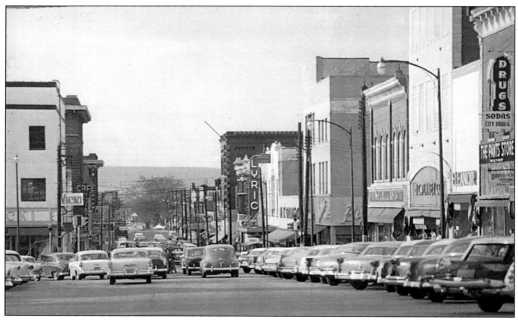

These two early 1950s views taken about the same time are of Washington Street looking north and show the businesses of the day including the Lyric Theater. The nickelodeon owned by Walter Humphrey and located at 112 Washington Street was purchased in 1912 by Charles A. Crute and Acklin Ragland and renamed the Lyric Theater. In 1929 the first talking picture in Huntsville, *My Man* starring Fannie Brice, was presented. A Christmas fire in 1930 destroyed four buildings, including the Lyric. It was rebuilt and opened December 1931. The Lyric and its marquee, long a landmark on Washington Street, closed for business in 1978 and was destroyed by a fire on January 8, 1982.

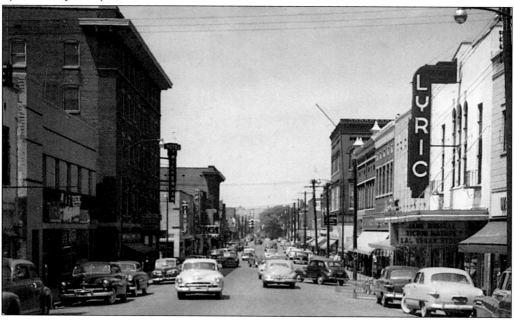

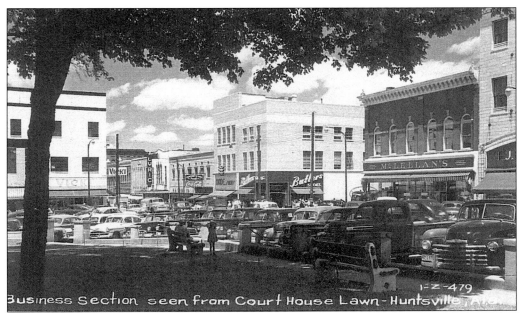

Business Section seen from Court House Lawn - Huntsville, Ala.

The top view is looking northeast from the courthouse lawn and shows the intersection of Washington Street and Randolph Avenue. While this intersection today primarily sees traffic from those doing business in the courthouse and surrounding law offices, it was one of the hubs of retail activities prior to the 1970s. The bottom view is looking south from the above intersection and shows the businesses and activities of the east side square. (Top card, courtesy of Charles Cataldo Jr.)

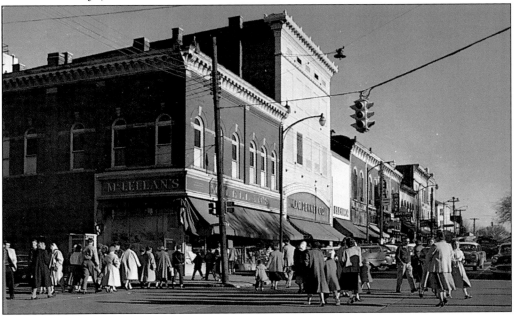

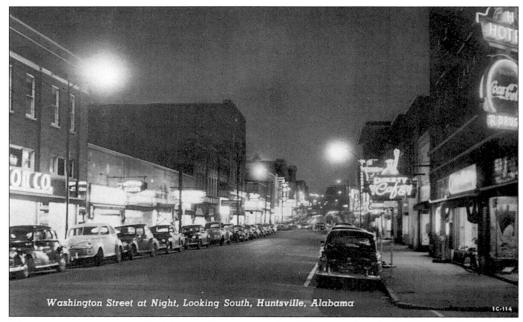

Washington Street at Night, Looking South, Huntsville, Alabama

These two views show Washington Street at night. The top view is looking south with the Twickenham Hotel to the right. The bottom view is looking north along Washington Street from the Randolph Avenue intersection.

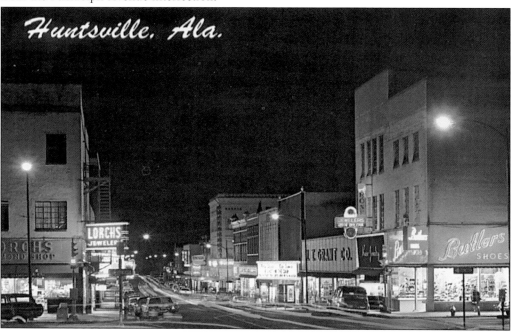

Seven

HOUSES

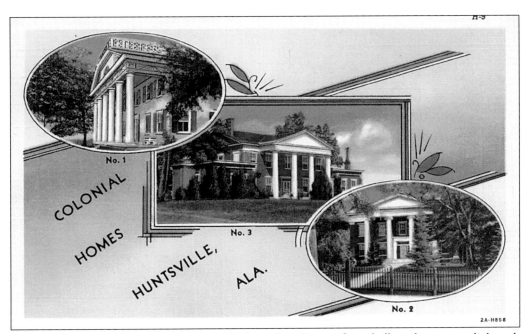

Huntsville, like many Southern towns, had an abundance of antebellum homes, and though many have been lost to "progress," many have survived the ravages of time, including these three: No. 1 The Leroy Pope home, No. 3 Oaklawn Plantation, and No. 2 The Bibb Home.

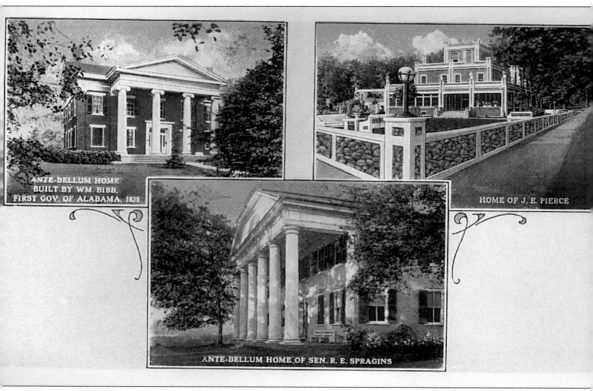

ANTE-BELLUM HOME BUILT BY WM. BIBB, FIRST GOV. OF ALABAMA, 1835

HOME OF J. E. PIERCE

ANTE-BELLUM HOME OF SEN. R. E. SPRAGINS

Huntsville has always been proud of its history, as can be seen through its use of historic buildings in early postcards, including this view of three antebellum homes. The Beirne Home, also known as the Bibb Home, c. 1837, was built by Thomas Bibb, the second governor of Alabama, for his daughter Adaline Bibb. The home of J.E. Pierce, though no longer in existence, was located in the present-day 700 block of East Holmes Avenue. Jacob Emory Pierce was the editor and general manager of the *Huntsville Daily Times*. The antebellum home of Senator Robert E. Spragins, also known as the Leroy Pope home, was built by Colonel Leroy Pope c. 1814.

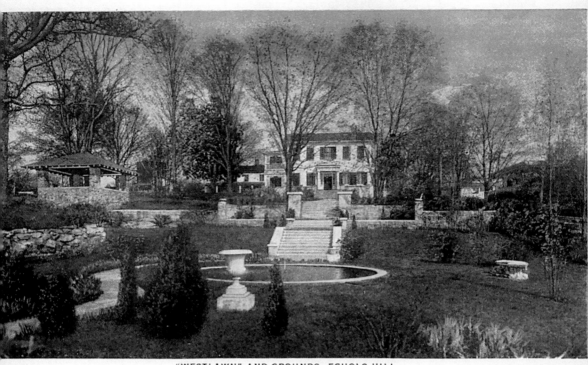

"WESTLAWN" AND GROUNDS, ECHOLS HILL

"Westlawn" and grounds, Echols Hill, was constructed in the early 1830s. This Greek Revival house was purchased by the grandson of Leroy Pope, Leroy Pope Walker, the first secretary of the Confederacy, after the Civil War. The picturesque front lawn contains the old city reservoir, which was converted into a sunken garden.

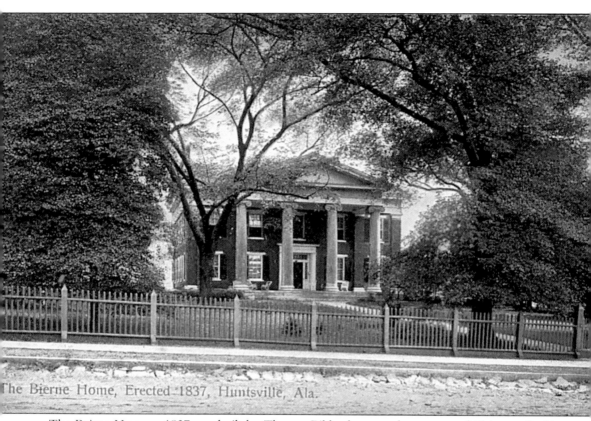

The Bierne Home, Erected 1837, Huntsville, Ala.

The Beirne Home *c.* 1837 was built by Thomas Bibb, the second governor of Alabama, for his daughter Adaline. Based on Bibb's home at Belle Mina it is another example of Greek Revival architecture in Huntsville. In the mid–1840s the home was sold to the Beirne family, who retained ownership for 76 years. In 1927 ownership of the property returned to descendants of the Bibb family and it remains in the family today.

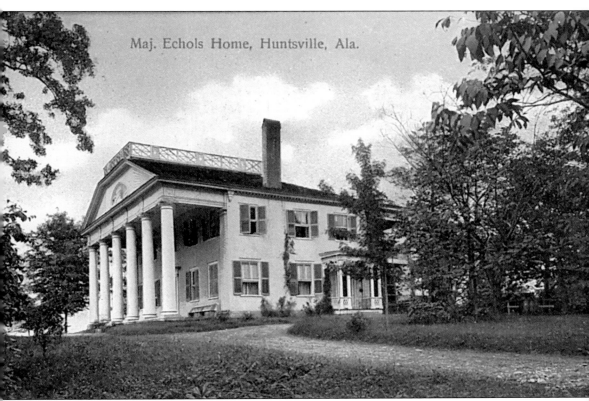

Maj. Echols Home, Huntsville, Ala.

"Maj. Echols Home," also known as "The Leroy Pope Mansion" and the "Pope-Patton Spragins House," was built by Col. Leroy Pope on the highest hill, also known as Echols Hill, overlooking the new town of Huntsville *c.* 1814. This two-story brick house is the oldest documented residence in Alabama. Local architect George Steele added the revival portico to the residence around 1850.

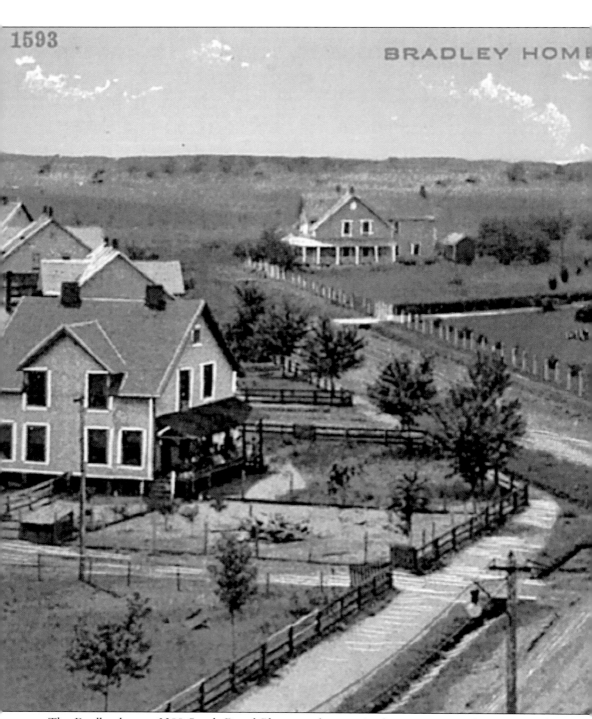

The Bradley home, 3300 South Broad Place, can be seen in the top center right. As agent for Merrimack Mills, Mr. Bradley had much influence and respect in the community. His residence was the largest and was centered in the middle of the company-developed community of "Merrimack." The Merrimack Hospital can be seen in the top center left. The row of houses on

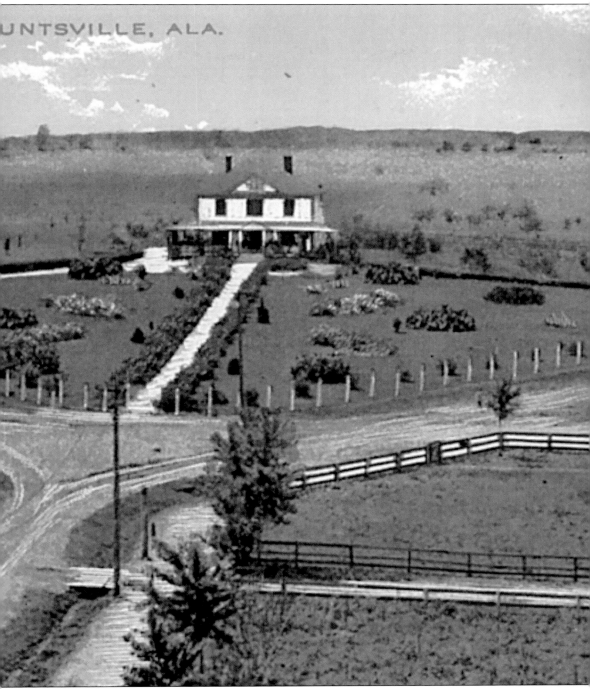

the left side of the picture was typical of the mill village housing available to its workers. These properties were eventually sold to workers beginning in October 1949. Most of the original Merrimack Mill Village housing is still in existence, including the house on the front left side of this card, located at the present-day 3501–3503 Alpine Street. (Courtesy of Charles Cataldo Jr.)

The Bradley Home at Merrimack,

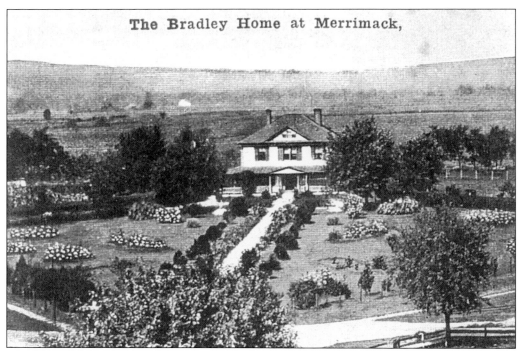

Shown here is the Bradley home at Merrimack. Joseph J. Bradley was the agent for Merrimack Mills, owner of one of Huntsville's largest cotton mills. While Merrimack Mills was demolished for salvage in the early 1990s, the Bradley home is still in use and is located on South Broad Place. (Courtesy of George and Peg Heeschen.)

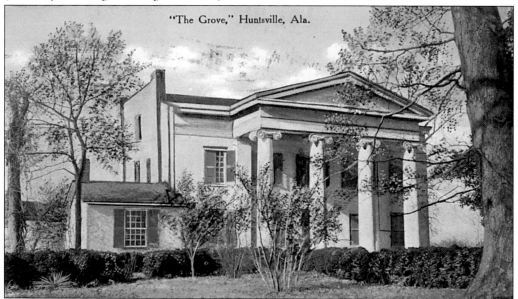

The "Grove," built in 1815 and demolished in the mid-1940s, was located approximately at what is now the Huntsville-Madison County Mental Health Center on Gallatin Street between Williams Avenue and Lowe Avenue.

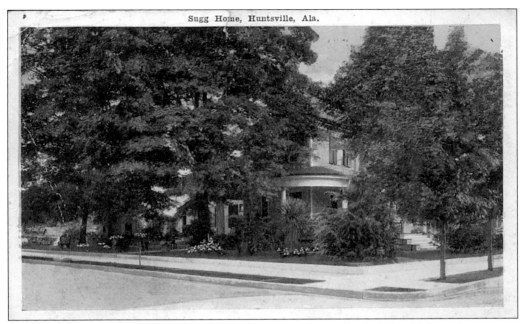

The Sugg home, also known as the Hewlett house, was located at 516 East Holmes Avenue, on the southwest corner of Holmes Avenue and Calhoun Street. This home burned in 1976 and was demolished in 1977.

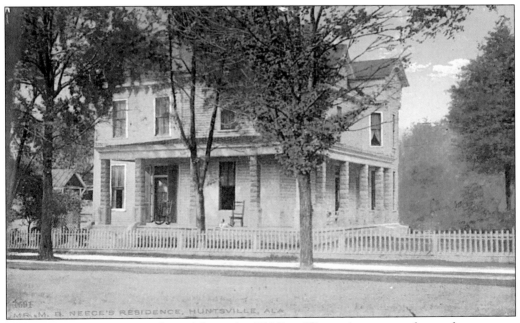

The c. 1889 M.B. Neece residence is located at 703 East Clinton Avenue, on the northeast corner of Clinton Avenue and White Street.

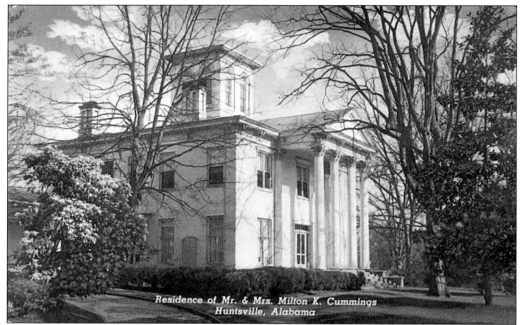

Residence of Mr. & Mrs. Milton K. Cummings
Huntsville, Alabama

The Milton K. Cummings residence, also known as the Watkins-Moore-Rhett house, at 603 Adams Street, was built *c.* 1826–1860. A black craftsman, Charles Bell from Charlottesville, Virginia, was brought here to build three spiral stairways. Two of the stairways led to the second floor, and the third, built around a large post, led to the tower on the roof. The tower has since been removed.

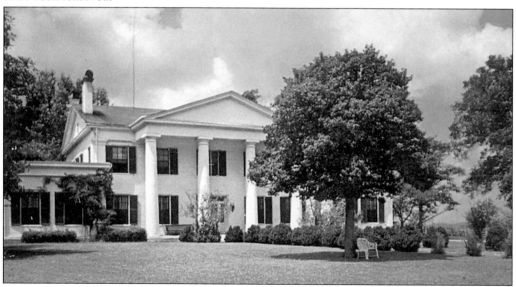

Oaklawn Plantation, also known as the John Robinson-Max Luther home, is located at 1620 Meridian Street (formerly known as Meridian Pike) and was built around 1844. John Robinson's brother, James Robinson, had nearly an exact duplicate of "Oaklawn," known as "Forestfield," which was located at Meridian Street near Oakwood Avenue. Unfortunately it burned during the Civil War.

Eight

SCHOOLS AND CHURCHES

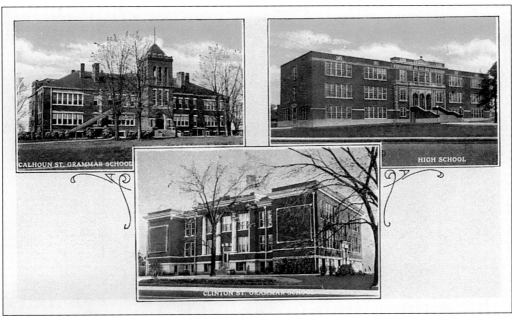

This postcard shows three different views of Huntsville's early school buildings. At the top left is the Calhoun Street Grammar School, built in 1902 and located on the site of the present East Clinton Elementary School; in the center is the Clinton Street Grammar School, constructed in 1916 as a separate high school on Clinton Street two blocks west of Jefferson Street; and at the top right is Huntsville High School, built in 1927 at the corner of Randolph Avenue and White Street (now the Annie C. Merts Center, home of the city of Huntsville schools' administrative offices).

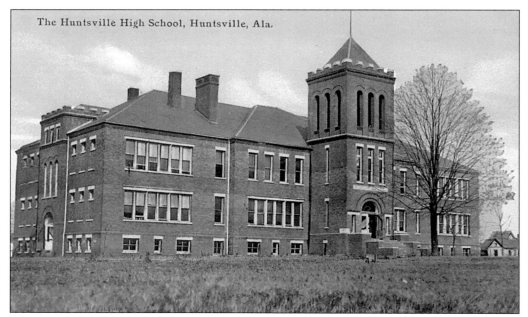

The Huntsville High School, Huntsville, Ala.

Pictured on the preceding page as the Calhoun Street Grammar School, this is Huntsville High School. It was built in 1902 and is located on the site of the present East Clinton Elementary School. This site has been continuously used for educational facilities since 1822.

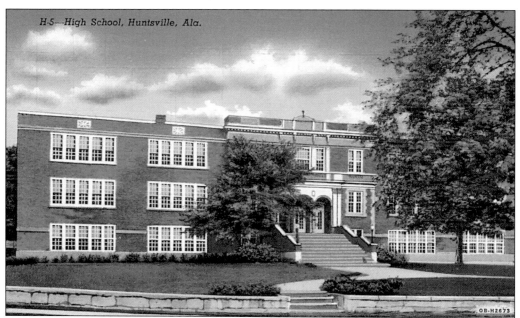

H-5—High School, Huntsville, Ala.

Due to Huntsville's boom and growing high school population of the 1920s, this high school building was built in 1927 at the corner of Randolph Avenue and White Street. Upon completion of the current Huntsville High School, located on Billie Watkins Street, this building became Huntsville Middle School and is now the Annie C. Merts Center, home of the city of Huntsville schools' administrative offices.

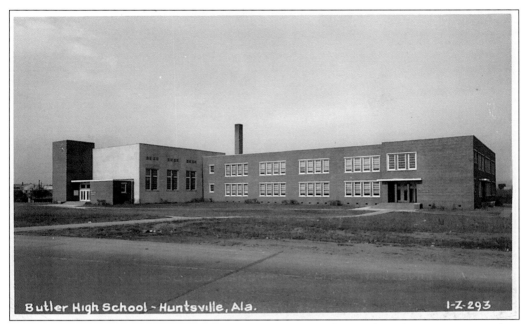

Butler High School was named after longtime educator Samuel R. Butler, who was superintendent of Huntsville Schools in 1893 and of Madison County Schools from 1906 until his death in 1931. After the new Butler High School on Holmes Avenue opened in the late 1960s, this school was renamed Roy L. Stone Junior High School and later Roy L. Stone Middle School. Several additions were built onto it over the years. The original structure, shown here, was destroyed by fire in the early 1980s.

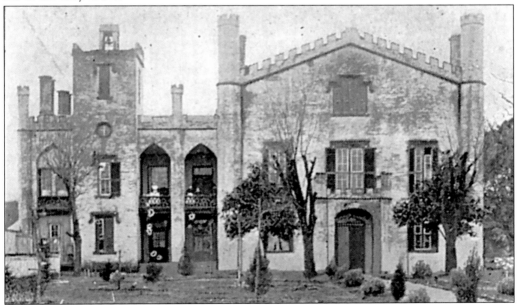

This is a view of the "State School" Huntsville, better known as Huntsville Female Seminary. This building was located on Randolph Avenue and was built by George Steele in 1854–55. It was demolished in 1912.

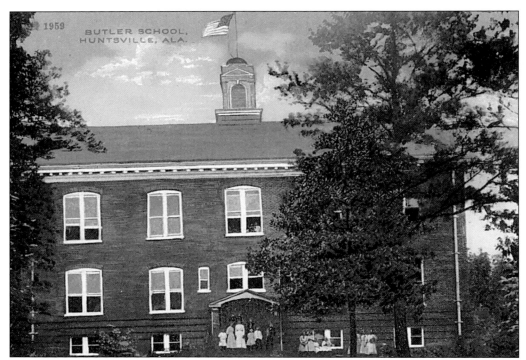

This building of the Butler School, also known as "The Butler Training School," was designed by Huntsville architect Edgar L. Love and constructed in 1909. It was located on what is now the southwest corner of Andrew Jackson Way and Wells Avenue. Professor Samuel R. Butler, also the Madison County superintendent of schools, ran the Butler Training School from 1908 until 1913. This building housed a total of five prominent private schools before becoming part of the Huntsville City School System in 1929. It was torn down in 1962.

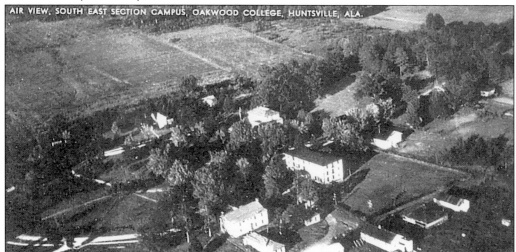

Oakwood College, founded in 1896 as a four-year co-educational Seventh-Day Adventist institution, has historically been an African-American college. It is located on 1,185 acres in the northwest quadrant of Huntsville with an average enrollment of 1,600 students, including many from foreign countries. (Courtesy of Charles Cataldo Jr.)

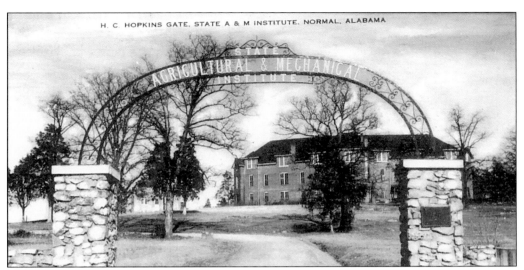

The H.C. Hopkins Gate at the State Agriculture & Mechanical Institute was erected in 1933 by the Chicago Normalite Club in honor of longtime faculty member H.C. Hopkins.

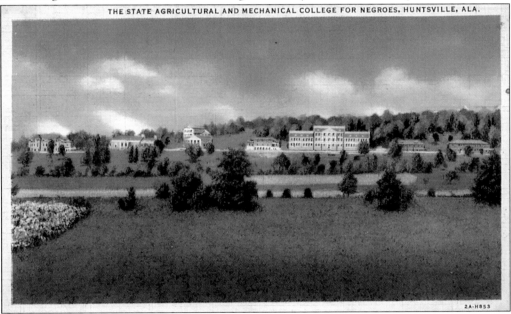

THE STATE AGRICULTURAL AND MECHANICAL COLLEGE FOR NEGROES, HUNTSVILLE, ALA.

This is a panoramic view of the State Agricultural and Mechanical College for Negros, which is now known as Alabama Agricultural and Mechanical University. On December 9, 1873, the state legislature approved a "normal school for the education of colored teachers" in Huntsville. Ex-slave William Hooper Councill was founder and first president. Classes began May 1875 in a rented building and moved in 1881 to school-owned property on West Clinton Street (now West Clinton Avenue, near present-day Monroe Street). In 1891 it became a negro land grant college, with the acceptance by the state of Alabama of the Second Morrill grant after passage of the Second Morrill Act in 1890. To qualify as a land grant institution, the school had to provide agriculture education, so in the summer of 1891 the school relocated to its present location in North Huntsville.

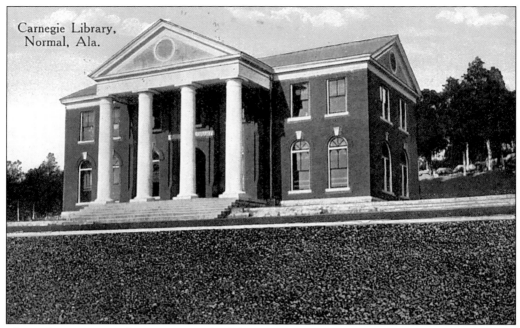

This is the Carnegie Library in Normal, Alabama.

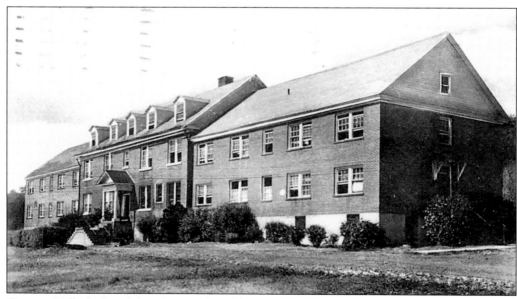

Grayson Hall, the boys' dormitory at the Alabama Agricultural and Mechanical College, Normal, Alabama, is the subject of this postcard.

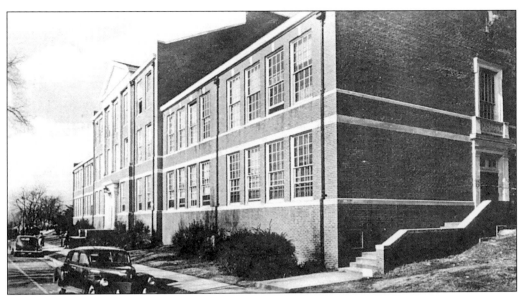

Bibb Graves Hall, also known as the Academic Building, is pictured here.

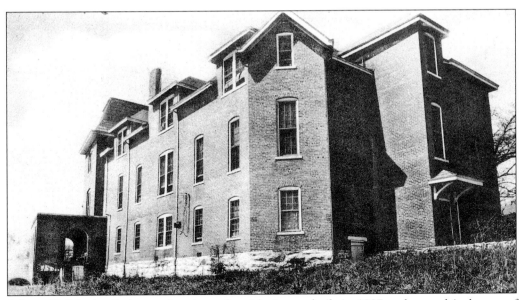

Palmer Hall is the freshmen dormitory for girls. It was built in 1897 and named in honor of Solomon Palmer, state superintendent of education.

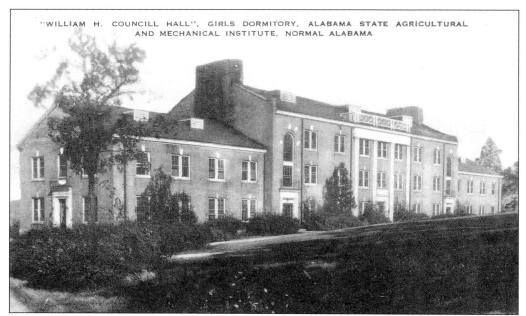

"WILLIAM H. COUNCILL HALL", GIRLS DORMITORY, ALABAMA STATE AGRICULTURAL AND MECHANICAL INSTITUTE, NORMAL ALABAMA

William H. Councill Hall, another girls dormitory, was renovated and renamed James H. Wilson in April 1990. It now houses the Alabama Black Archives Research Center and Museum.

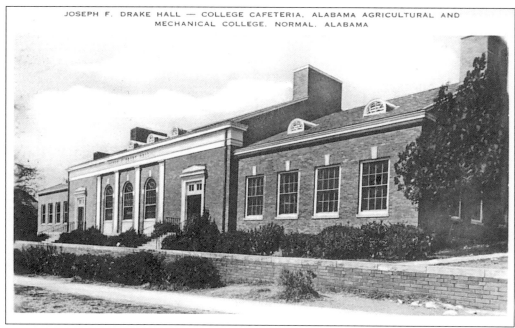

JOSEPH F. DRAKE HALL — COLLEGE CAFETERIA, ALABAMA AGRICULTURAL AND MECHANICAL COLLEGE, NORMAL, ALABAMA

Joseph F. Drake Hall is the cafeteria at the college.

The Episcopal Church of the Nativity of Huntsville, Alabama, was built 1858–59 and located at the southwest corner of Eustis Avenue and Greene Street. Ordered to stable horses inside the church during the Civil War, a Union officer refused to obey the command after reading the words "Reverence My Sanctuary" engraved over the entrance.

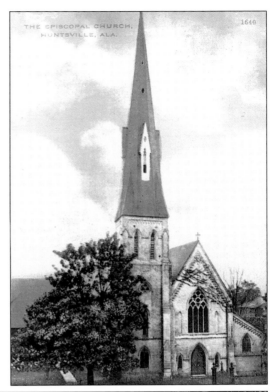

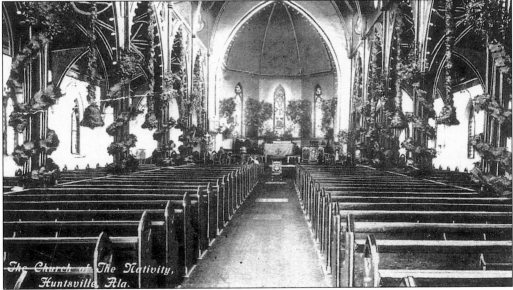

This view of the Church of the Nativity, also known as the Episcopal Church of the Nativity, shows the ornate interior with Christmas greenery. The image, recorded on a postcard, is only fitting, as the Church of the Nativity was so named because of the upcoming Christmas season when an organization of a parish was effected on December 17, 1842. (Courtesy of the Huntsville-Madison County Public Library.)

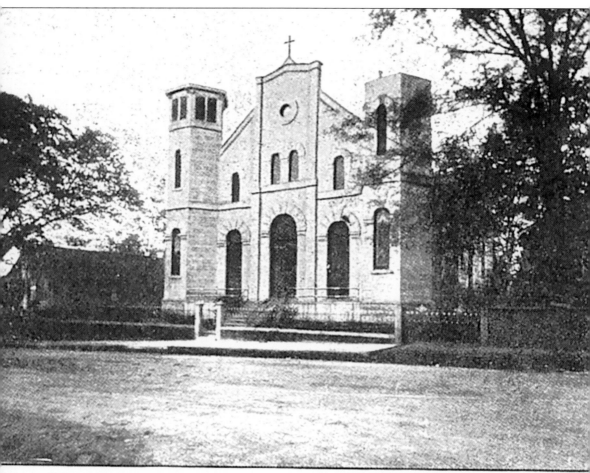

ST. MARY'S CATHOLIC CHURCH, HUNTSVILLE, ALA.

Father Jeremiah Frederick Trecy was the founding father of St. Mary's Catholic Church in 1861, at which time he began work on a building made of native rock from Monte Sano Mountain. When the Civil War came in 1861 the building was completed up to the cornerstone, but work would halt there until the end of the war. Though work on the building resumed after the end of the war, financial setbacks delayed completion of the building until 1872. This building is still in daily use as St. Mary of the Visitation Church, located at 222 N. Jefferson Street.

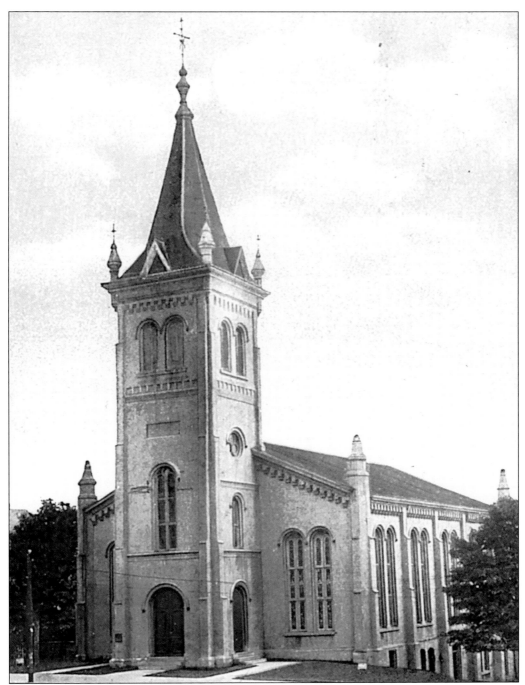

The present First Methodist Church located at 219 Randolph Avenue (at the northwest corner of Randolph and Greene Streets) had its cornerstone laid August 7, 1867, and was completed in 1870. The building was constructed to replace a previous sanctuary that was destroyed by fires in 1864 (the fires were built on the basement floor for warmth and food preparation during occupation by Federal troops).

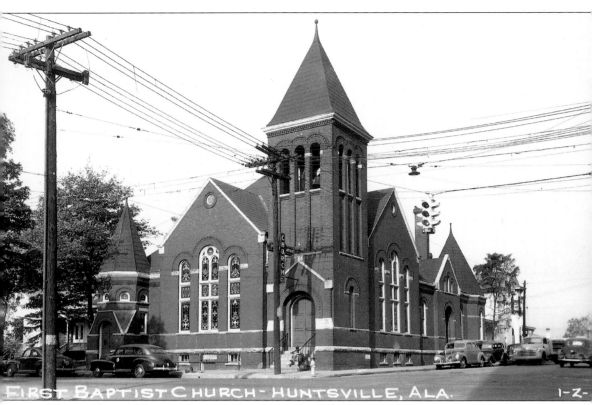

FIRST BAPTIST CHURCH - HUNTSVILLE, ALA. 1-Z-

This building of the First Baptist Church was located at the northwest corner of West Clinton Avenue and Gallatin Street (now West Clinton and Spragins Avenues). Built in 1894, it was demolished in 1963.

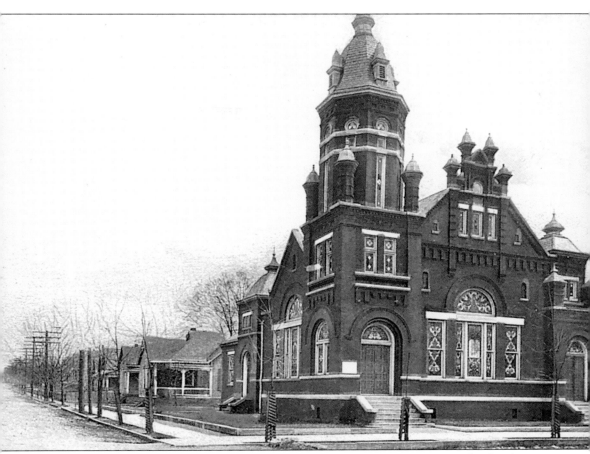

The first Jewish citizens arrived in Huntsville in the 1840s. On July 30, 1876, 32 families (some records say 18 local men) of the Jewish faith organized the first Jewish temple in Huntsville, named B'Nai Sholom ("Sons of Peace"). After some 21 years of holding religious service at several different local meeting halls, the small congregation built this temple *c.* 1898. This Jewish Synagogue, the Temple B'Nai Sholom, is located at the southeast corner of Clinton Avenue and Lincoln Street and has been in continuous use since. One of the houses in background is still in existence (406 Clinton Avenue), though in a state of disrepair.

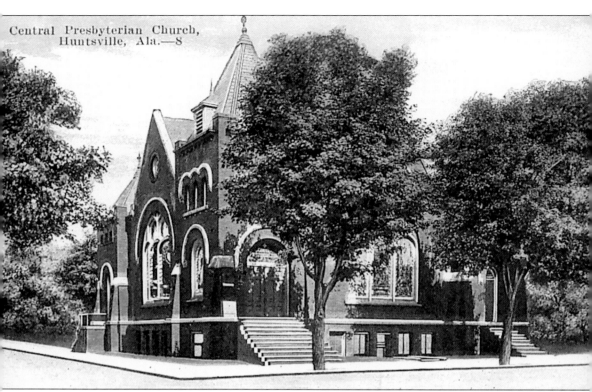

Central Presbyterian Church,
Huntsville, Ala.—8

The Central Presbyterian Church is located at the southeast corner of Lincoln Street and Randolph Avenue. This building, the church's third (and the second at this location), was built in 1899 and has been in use since then. Originally, church members planned to buy the property next to it on Lincoln Street so the church building could be enlarged considerably. However, as they were unable to acquire the adjoining property, this building had to be built high instead of wide and flat. The brick used in the lower wall of this building constitutes the brick of the old church (the second building).

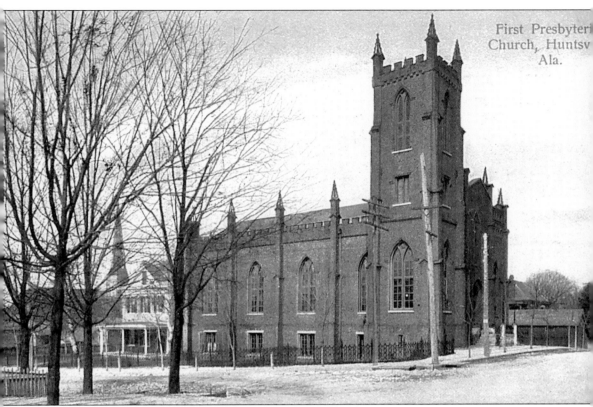

First Presbyterian Church, Huntsville Ala.

The First Presbyterian Church, located at 312 Lincoln Street (on the northwest corner of Lincoln Street and Gates Avenue), was dedicated on May 18, 1860. Organized on June 15, 1818, this is the oldest Presbyterian church in the state of Alabama. The brick Gothic Revival edifice replaced an earlier 1822 white frame church at the same location. Upon its completion, it had the tallest steeple (the tower and spire were 170 feet) in Huntsville, but it was destroyed during an April 17, 1878 storm and was never replaced.

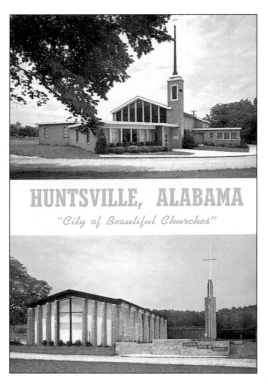

St. Marks Lutheran Church was formally organized in Huntsville on October 31, 1951. This building of St. Marks (top) was built in the late 1950s at 200 Longwood Drive, the southeast corner of Longwood and Franklin Streets. It replaced a building and site purchased in 1951, along with two lots purchased in 1952. The First Christian Church (bottom) was founded in 1947 with a charter membership of 20 people. The first building was located at Bob Wallace Avenue and Alabama Street and was dedicated on July 11, 1948. The building seen in this view is located at their present campus on the east side of Whitesburg Drive, just south of Drake Avenue. It was converted into a gymnasium after the addition of a new sanctuary.

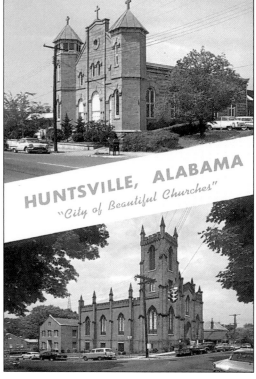

Though both of these churches, St. Mary of the Visitation Church (top) and the First Presbyterian Church (bottom), have been pictured on the preceding pages, these views show the buildings in their modern (late 1950s) surroundings.

Nine

HOTELS AND MOTELS

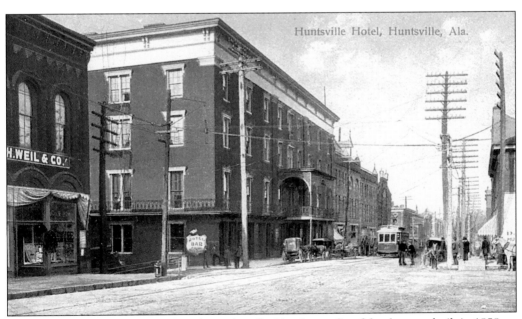

Huntsville Hotel, Huntsville, Ala.

The Huntsville Hotel, a luxury hostelry as described by the media of the day, was built in 1858 on the site of the Bell Tavern and located at the northwest corner of what is now Spring Avenue and Jefferson Street. For many years the Huntsville Hotel remained a popular and elegant landmark. But it too eventually met the fate of its predecessor and was destroyed by fire in 1910. The 1948 building of the Henderson National Bank, which is now occupied by SouthBank, is currently located on the site.

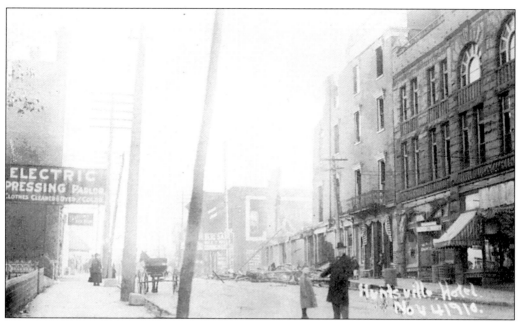

The Huntsville Hotel fire of November 4, 1910, destroyed the 1858 building but left a later annex on the right side of the hotel intact. (Courtesy of the Huntsville-Madison County Public Library.)

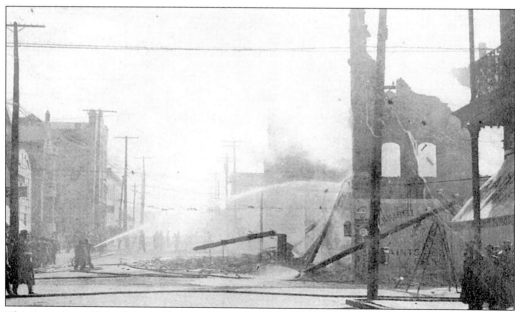

This is a view of the Huntsville Hotel Annex fire of November 11, 1911. This fire destroyed the annex (which survived the November 4, 1910 fire) and the Grand Opera House next door. (Courtesy of the Huntsville-Madison County Public Library.)

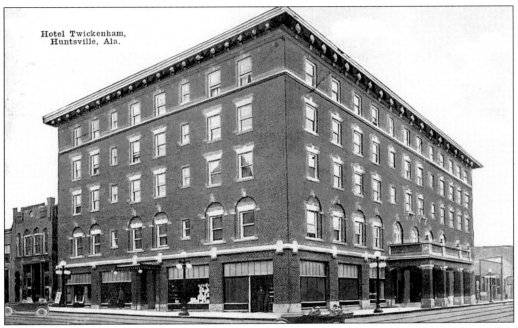

Hotel Twickenham, Huntsville, Ala.

Groundbreaking ceremonies were held in April 1914 for the Twickenham Hotel, Huntsville's first fire-proof hotel. Built at the southwest corner of Washington Street and Clinton Avenue, the Twickenham Hotel opened for business in March 1915. Being fire-proof prevented the hotel's demise by fire, which claimed many of Huntsville's early and grand hotels, but the wrecking ball claimed the Twickenham in 1975.

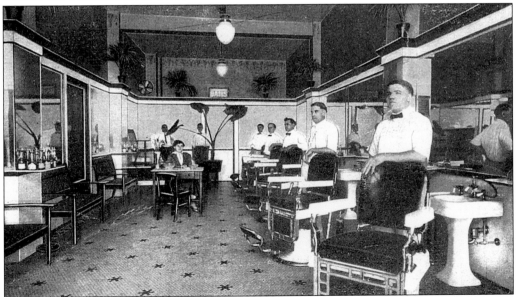

As with many hotels of the day that had auxiliary businesses such as cafes, coffee and gift shops, bars, and pool halls located within or on the premises, the Hotel Twickenham was no exception. Pictured is the Hotel Twickenham shop, which appears to be a well-appointed barber shop and beauty salon. (Courtesy of George and Peg Heeschen.)

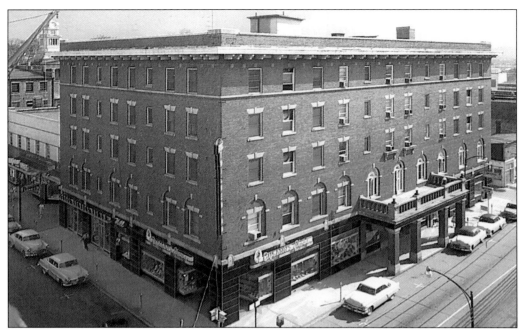

This is a view from the late 1950s of the Twickenham Hotel, with the clock tower of the third Madison County Courthouse in the upper left background. The Twickenham closed to guests in 1971 and was demolished in 1975 to make room for a new municipal parking garage.

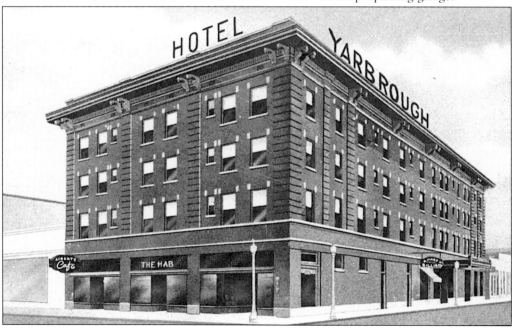

The four-story, 80-room Hotel Yarbrough was opened in 1924 as a strictly commercial hotel catering to businessmen, as it had no banquet or ballroom facilities. This hotel, like many of its time, fell victim to the new motels and closed. The building is still standing at the corner of Jefferson Street and Holmes Avenue and is presently used as an office complex.

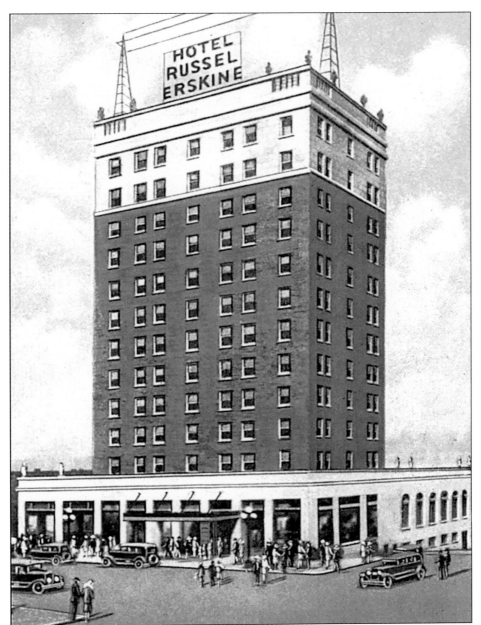

The 150-room, 12-story Hotel Russell Erskine was built 1928–29 and opened in January 1930. Located at the corner of Clinton Avenue and Spragins Avenue, it has been a towering fixture of Huntsville's landscape since its construction. Named after Huntsville native Mr. Russell Erskine, the president of Studebaker Corporation, in an attempt to entice his investment in the project (which he did on a very limited basis), the Russell Erskine Hotel dominated Huntsville's social life as "the hotel" until the mid-1960s. As businesses were leaving downtown for locations such as the Memorial Parkway corridor, which included an abundance of new motels, patronage began to fall for the Russell Erskine Hotel and it closed in the early 1970s. The building has been renovated and is currently used as a high-rise apartment complex for the elderly and disabled.

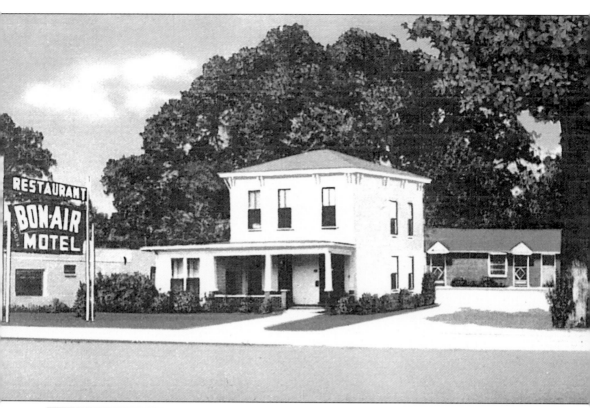

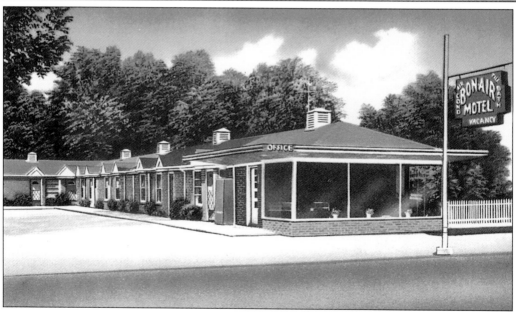

The Bon-Air Motel and Restaurant was established on May 26, 1951, at 508 Meridian Street by Mr. and Mrs. R.E. Hicks. The motel was operated by Mr. and Mrs. R.E. Hicks while the restaurant was operated by Mr. and Mrs. Olan Hicks.

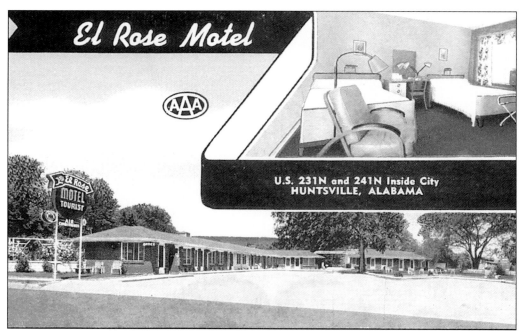

The El Rose Motel was located on Meridian Street just north of Pratt Avenue. This building is still standing and being used for office and retail space.

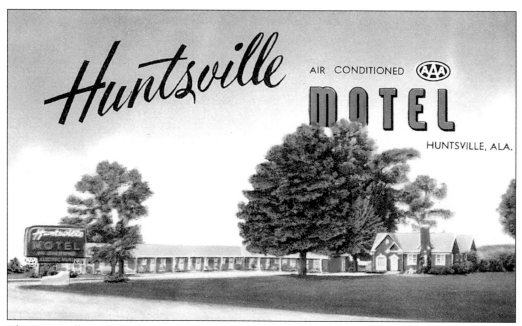

The Huntsville Motel, more recently known as the Bentley Motel, was located at the southwest corner of Meridian Street and Mountainview Drive. Due to its deteriorating state, it was burned in the late 1990s. Unlike the indignity that many similar structures suffered, its demise in flames benefited the Huntsville Fire Department as a training exercise.

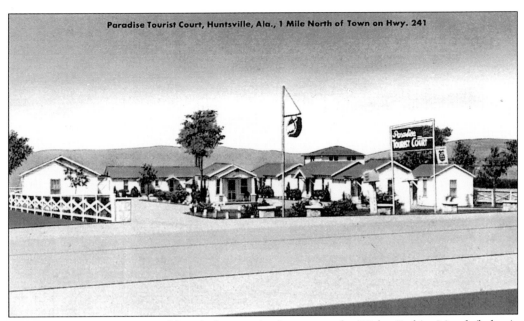

Paradise Tourist Court, Huntsville, Ala., 1 Mile North of Town on Hwy. 241

The Paradise Tourist Court (above), later to be known as the Wake Robin Motel (below), was located at the northwest corner of Meridian Street and Mountainview Drive. No longer in existence, it was one of many motels located along the Florida Short Route.

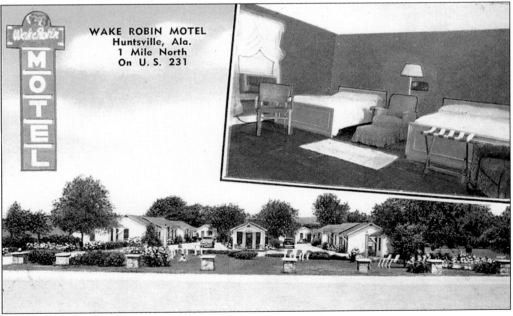

WAKE ROBIN MOTEL
Huntsville, Ala.
1 Mile North
On U. S. 231

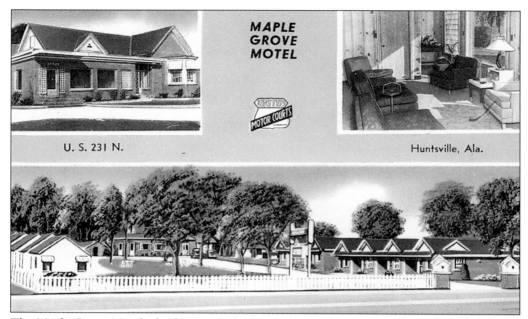

The Maple Grove Motel, also known as the Maple Grove Cottages, was located along the west side of Meridian Street south of Max Luther Drive. Maple Grove is still in existence serving as rental apartments.

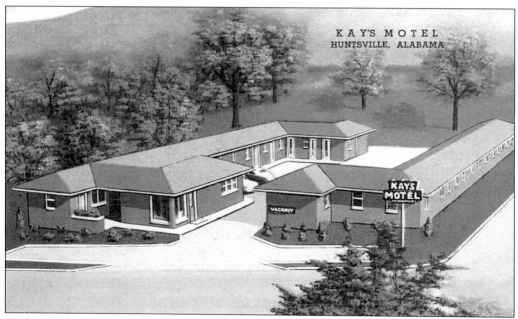

Kay's Motel, no longer in existence, was located at 900–911 S. Madison Street near the present intersection of Governor's Drive. Kay's Motel advertised itself as being modern, and featured Beautyrest Mattresses.

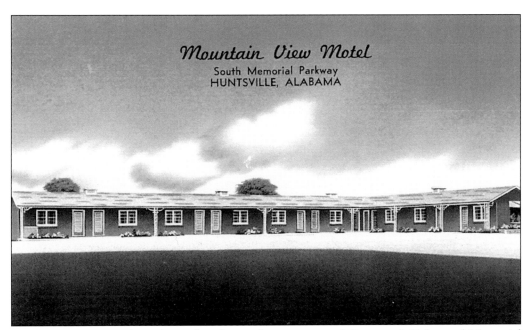

Mountain View Motel was located at the southwest corner of Governor's Drive and Memorial Parkway. Now gone, it was just north of the Goldenrod Motor Lodge, whose building is still in existence as office space surrounding El Palacio Mexican Restaurant.

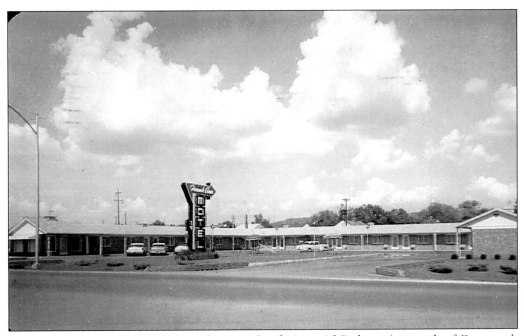

Frank Ann Motel was located along the east side of Memorial Parkway just south of Governor's Drive. This is a mid-1950s view before the installation of the swimming pool, which was subsequently filled during the construction of the Governor's Drive overpass. The main structure was demolished in the mid-1990s.

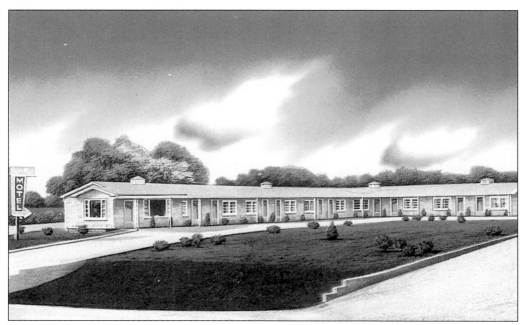

Her-Mar Motel (above), subsequently known as the Barclay Motel (below), was located along the west side of Memorial Parkway just north of Oakwood Avenue. In later years this hotel was razed and a two-story Days Inn motel constructed on its site. The swimming pool seen in the Barclay view was left in place and remains almost the same today except for higher brick fending and less grass, changes made during the construction of the Oakwood Avenue overpass.

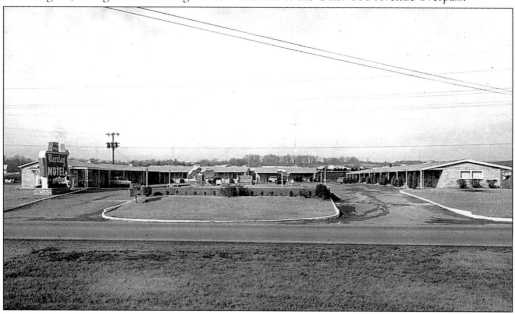

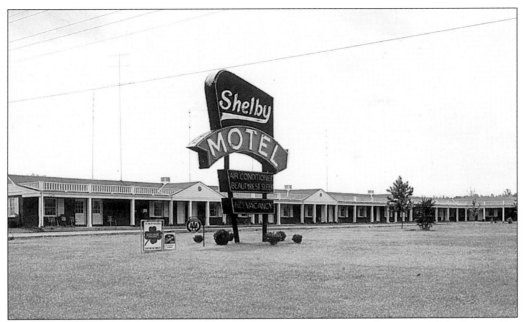

The Shelby Motel is still in existence and operation at 2209 North Memorial Parkway (the west side), just north of Oakwood Avenue and adjacent to the Barclay Motel shown on the previous page.

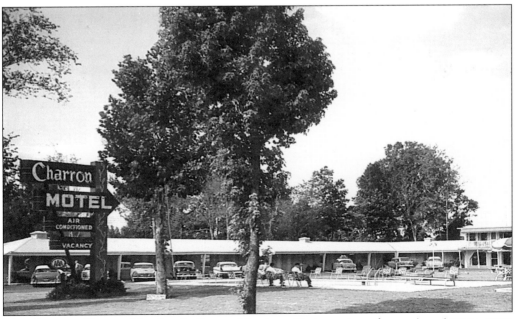

The 33-room Charron Motel and adjacent Morrisson Restaurant, no longer in existence, were located along the west side of Memorial Parkway just north of Country Club Drive.

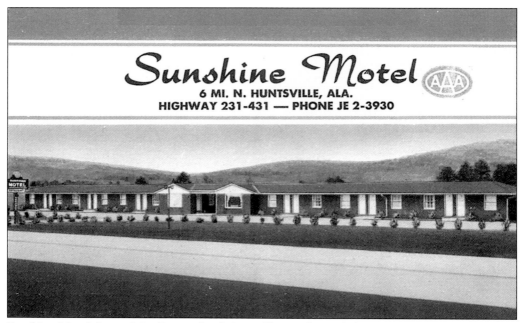

Sunshine Motel
6 MI. N. HUNTSVILLE, ALA.
HIGHWAY 231-431 — PHONE JE 2-3930

Sunshine Motel, located 6 miles north of Huntsville, was located along the west side of Highways 231 and 431 just north of Bob Wade Lane. This 12-room, subsequently expanded to 14-room, motel also featured Beautyrest Mattresses, and is still in use as apartments.

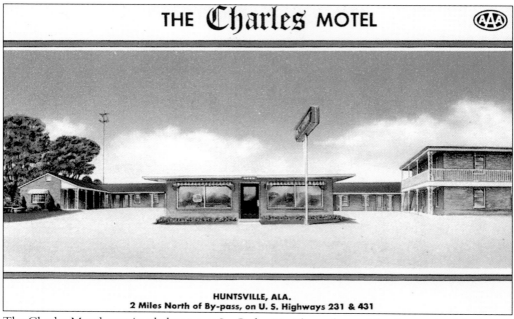

THE Charles MOTEL

HUNTSVILLE, ALA.
2 Miles North of By-pass, on U. S. Highways 231 & 431

The Charles Motel, previously known as La Carlos Motel, was located 2 miles north of the bypass (Meridian Street and the Parkway) on US Highways 231 and 431 in Meridianville, Alabama. Originally built as a typical L-shaped motel, subsequent additions include the center office and the two-story building to the right.

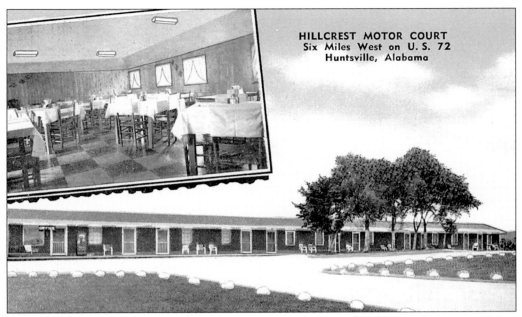

Hillcrest Motor Court was located 6 miles west of Huntsville on US 72, now University Drive, and in the city limits. This building was located on the south side of University Drive and was demolished in the mid-1990s. A Burger King restaurant is now located on this site at 6363 University Drive. (Courtesy of Charles Cataldo Jr.)

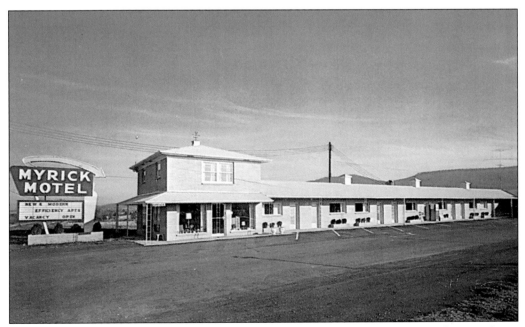

The 16-room Myrick Motel, though aged, is still in operation on the south side of US Highway 72 East, just west of Shields Road.

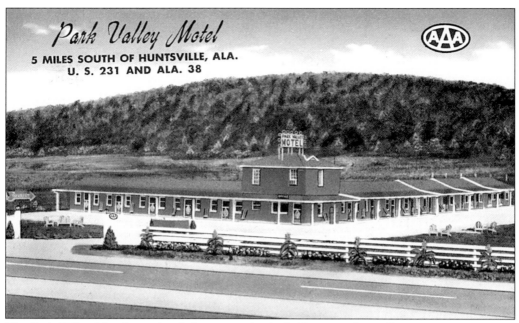

The Park Valley Motel, previously known as the Park Plaza Motel, is still in operation on South Memorial Parkway just north of Hobbs Road. As the city grew larger and closer with increased traffic on the parkway, the Park Valley advertised "all rooms 150 feet or more from highway" and "Brick units amply back on spacious lawns in scenic setting."

The Albert Pick Motel had 125 rooms and "ideal meeting facilities." Demolished in the mid-1980s, it was located at the southwest corner of the intersection of Memorial Parkway and Sparkman Drive.

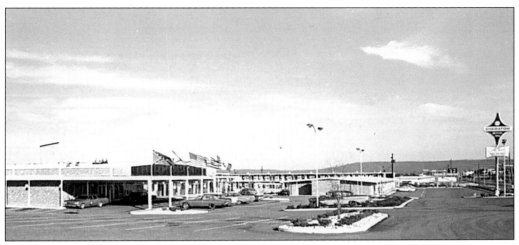

The Sheraton Motor Inn located on University Drive was the site of many high-profile functions in the 1960s and early 1970s. This motel, no longer affiliated with the Sheraton Chain, has been divided into numerous separate business activities, including three smaller motel chains, retail and office space, and adult entertainment.

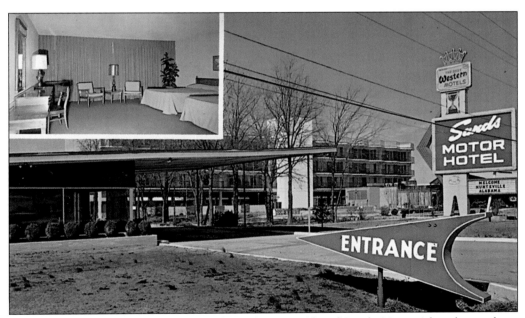

The Sands Motor Hotel was located along the west side of South Memorial parkway about midway between Drake and Bob Wallace Avenues. This structure was renovated in the mid-1990s as an office building.

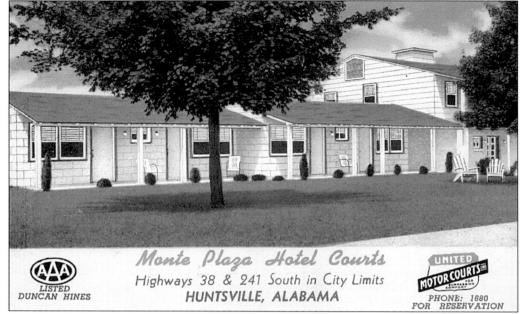

The Monte Plaza Hotel Courts, later known as Monte Plaza Motel, was located along the west side of Whitesburg Drive between Longwood Drive and Marsheutz Avenue. The Monte Plaza advertised itself as "featuring large rooms, luxuriously furnished with Simmons Metal Furniture and Beautyrest Mattresses." The adjoining hospitality house dining room advertised itself as "an atmosphere of hospitality from the Old South combined with only the highest quality of foods."

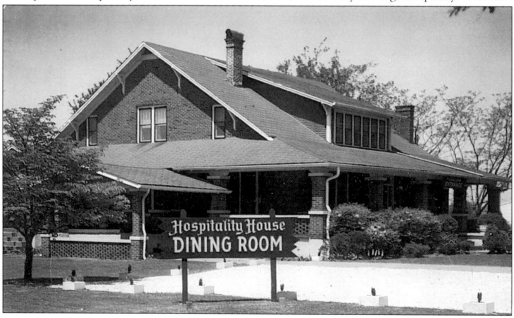

Ten

GENERAL
POSTCARD VIEWS

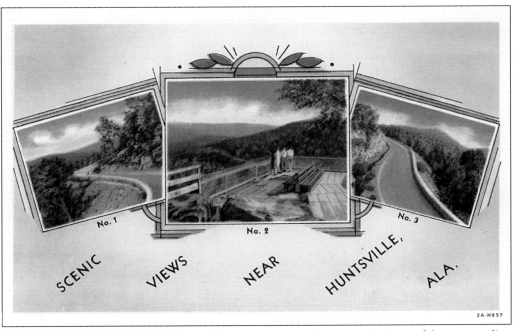

The hills and mountains of Huntsville offer many scenic and panoramic views of the surrounding valleys and countryside, including the scenes portrayed here: 1) a gorgeous scenic drive to Huntsville; 2) inspiration point, with an elevation of 2,000 feet, overlooking Huntsville; and 3) "Over the Top," Monte Sano Mountain, again at an elevation of 2,000 feet.

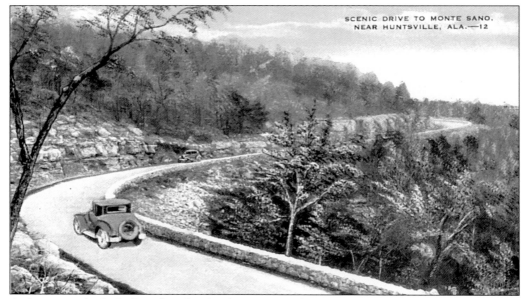

As better roads, including the Florida Short Route that passed through Huntsville (which is shown in the bottom view), became prevalent, mapped, and advertised, automobiles became more commonly used for both daily and scenic driving along with vacation travel. Subsequently, postcards showing these scenic views and routes came into use as souvenirs and methods of sending photo memories to one's friends and family.

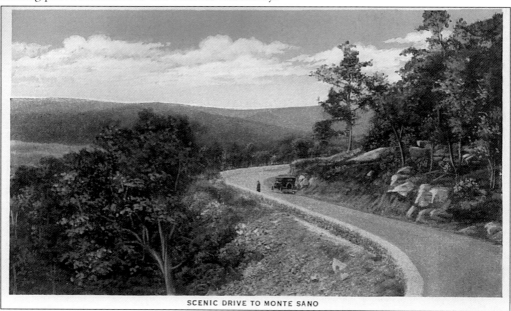

SCENIC DRIVE TO MONTE SANO

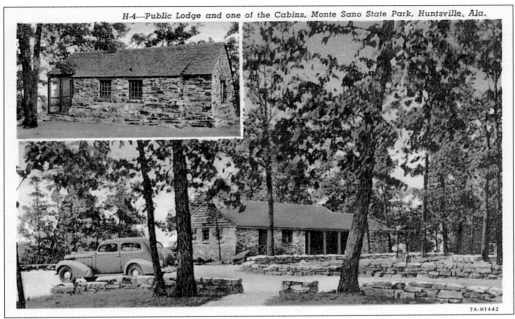

H-4—Public Lodge and one of the Cabins, Monte Sano State Park, Huntsville, Ala.

7A-H1442

Construction was begun on Monte Sano State Park in August 1935 by the Civilian Conservation Corps (CCC) after Madison County had purchased 2,000 acres and given it to the state for construction of a state park. The park was dedicated on August 25, 1936, and included the Public Lodge (also known as the Monte Sano Tavern) and cabins. These cabins were modern, fully equipped, and built from stone obtained on Monte Sano. They are still available for rental today. The Public Lodge/Tavern burned in the early 1990s. (Bottom image, courtesy of the Huntsville-Madison County Public Library.)

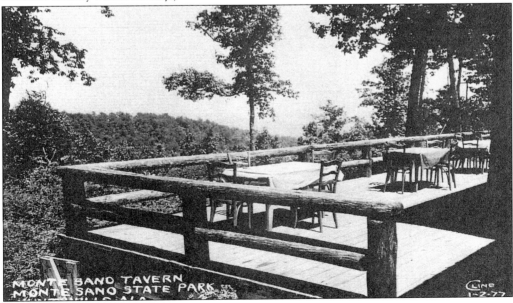

MONTE SANO TAVERN
MONTE SANO STATE PARK
CLINE
1-2-77

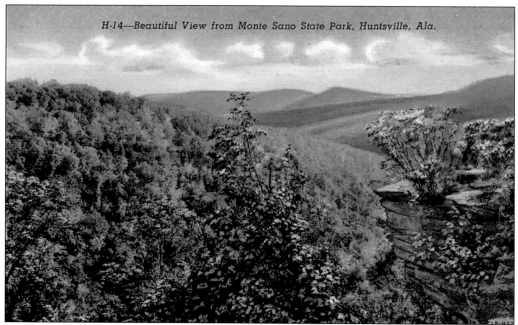

H-14—Beautiful View from Monte Sano State Park, Huntsville, Ala.

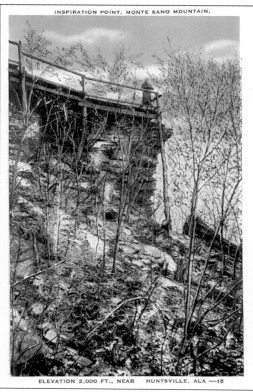

INSPIRATION POINT, MONTE SANO MOUNTAIN,

ELEVATION 2,000 FT., NEAR HUNTSVILLE, ALA.—15

Monte Sano Park offers many spectacular views of Huntsville, including Inspiration Point, which is located at an approximate elevation of 2,000 feet. This point is now located on private property at the end of Inspiration Lane.

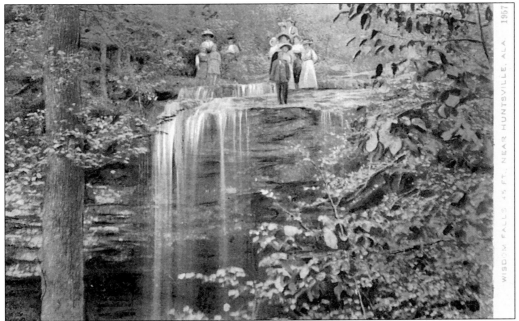

Wisdom Falls (above) and Vanishing
Falls (below left), also known as Monte
Sano Falls, are two of the many falls and
natural rock formations located on Monte
Sano and the surrounding mountains.

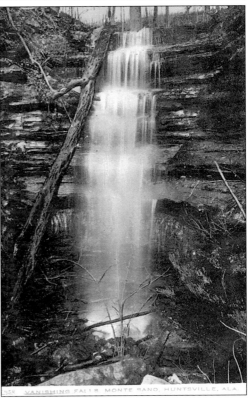

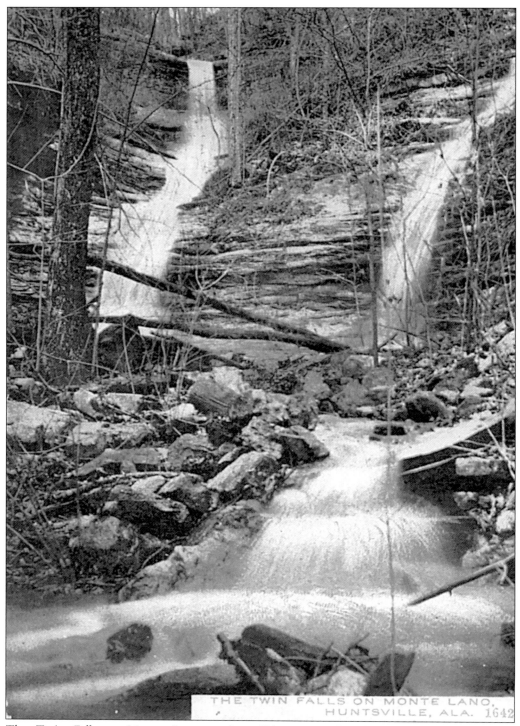

THE TWIN FALLS ON MONTE LANO.
HUNTSVILLE, ALA. 1642

The Twin Falls on Monte Sano are beautiful wet weather falls located within Monte Sano State Park.

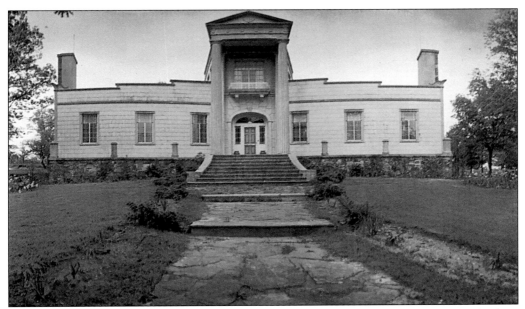

The Burritt Museum, the former home of W.H. Burritt, was built in 1937. Upon his death in 1955 it was willed to the city of Huntsville. The Burritt House/Museum is located on Round Top Mountain, at the southern end of Monte Sano, and was built in the unusual shape of a Maltese Cross with bales of straw within the walls being used for insulation.

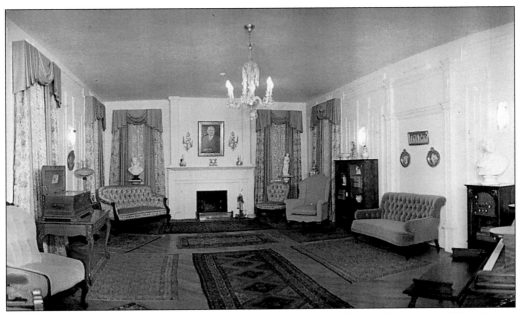

This interior view of the Burritt Museum shows the parlor with an oil painting of Dr. Burritt over the mantel.

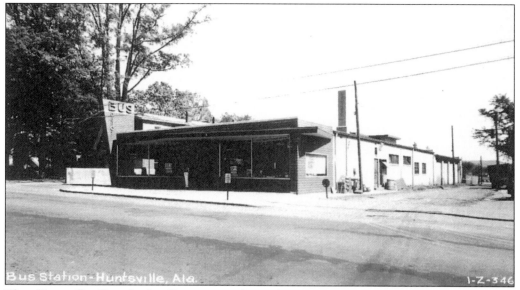

Bus Station-Huntsville, Ala. 1-Z-346

The Huntsville Bus Station/Depot was located on the south side of Clinton Avenue justwest of the present intersection of Monroe Street. (Courtesy of the Huntsville-Madison County Public Library.)

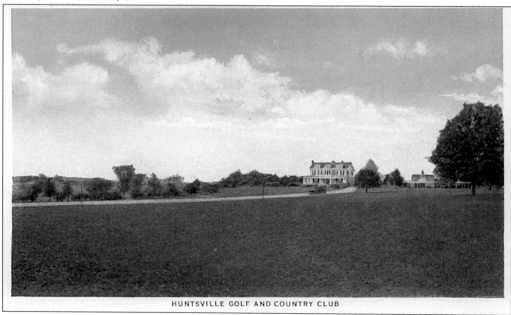

HUNTSVILLE GOLF AND COUNTRY CLUB

Here is a 1926 view of the Moss-Home Clubhouse of the Huntsville Golf and Country Club, established in 1925 at what is now a tract of land located in the southwest corner of Oakwood Avenue and Pulaski Pike. The tennis courts and carriage house can be seen to the right of the main house. The clubhouse burned to the ground August 19, 1933, and during the period of 1933–1949 the carriagehouse was renovated and served as the clubhouse. The Moss Home, previously known as Orchard Place, was the home of Maj. Milton Moss and was originally called Hilltop. When purchased by the Huntsville Country Club in 1925, it included 228 acres.

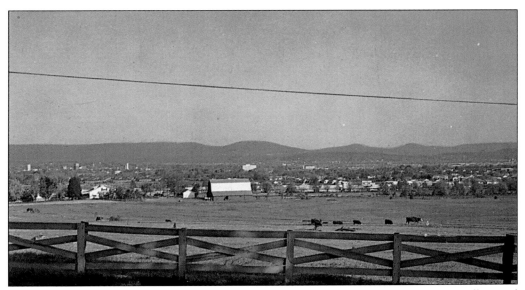

The hills and mountains of Huntsville offer many panoramic views of the surrounding valleys and countryside. These are just two of many used on postcards over the years.

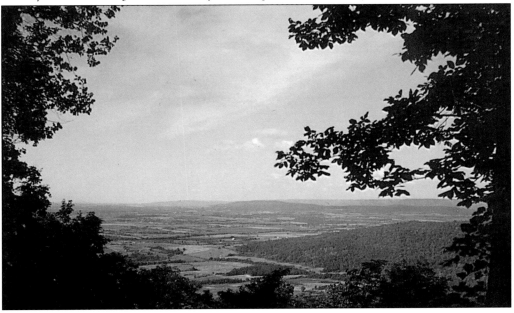

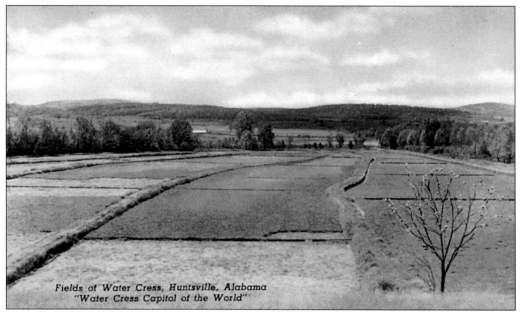

Fields of Water Cress, Huntsville, Alabama
"Water Cress Capitol of the World"

Watercress is the most ancient of all known green vegetables and has been eaten since the time of the ancient Greeks and Romans. During the period when Huntsville was known as the "Watercress Capital of the World," production of watercress during the winter months supplied well over half the needs of the American market.

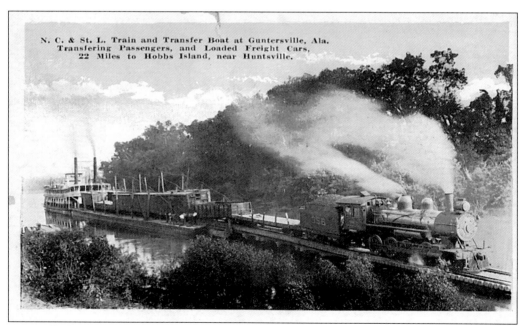

N. C. & St. L. Train and Transfer Boat at Guntersville, Ala.
Transfering Passengers, and Loaded Freight Cars,
22 Miles to Hobbs Island, near Huntsville.

Huntsville had several railroad lines running east to west or northeast, but only the Nashville, Chatanooga, and St. Louis ran south-southeast. Due to the mountainous terrain of this area it was necessary to transfer the railroad and passenger cars by barge from Hobbs Island landing to Guntersville by way of the Tennessee River.

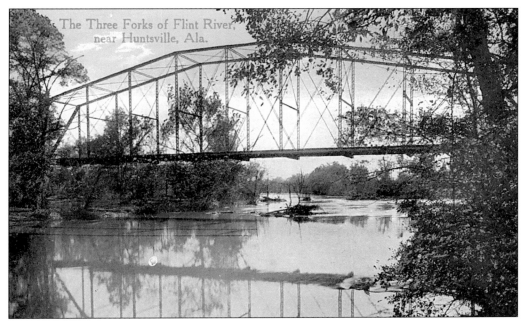

The three forks of the Flint River are located near Winchester Road and Riverton Road. This area was the site of many weekend outings and social gatherings in the late 1800s and early 1900s.

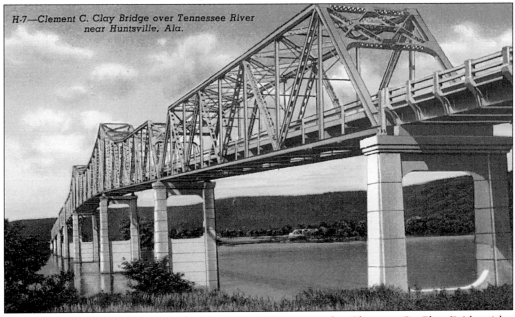

US Highway 231 south crosses the Tennessee River over the Clement C. Clay Bridge (also known as the Whitesburg Bridge) in what used to be the area of Ditto Landing. The approximate spot of the Ditto Ferry Landing can be seen in the bottom center background.

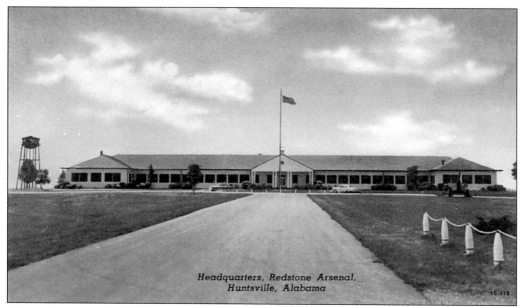

Headquarters, Redstone Arsenal,
Huntsville, Alabama

This building is the "Headquarters, Redstone Arsenal, Huntsville, Alabama." The army announced on November 4, 1949, that the rocket office at Fort Bliss, Texas, with Dr. Wernher Von Braun, was to be transferred here. Huntsville eventually became known as "Rocket City, USA."

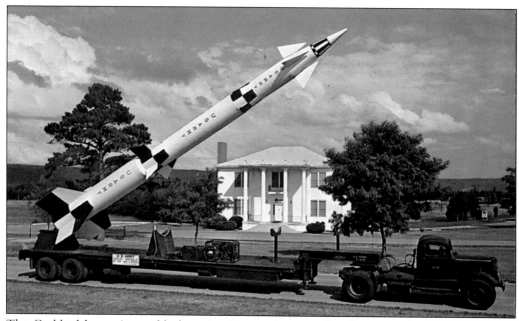

The Goddard house is an old plantation house taken over by the army when the "Huntsville Arsenal" was established near Huntsville in 1941. The arsenal, with the purpose of manufacturing chemical weapons, was announced July 3, 1941, and was to have an expenditure in excess of $47 million and consist of some 30,000 acres south and southwest of the city extending to the Tennessee River.

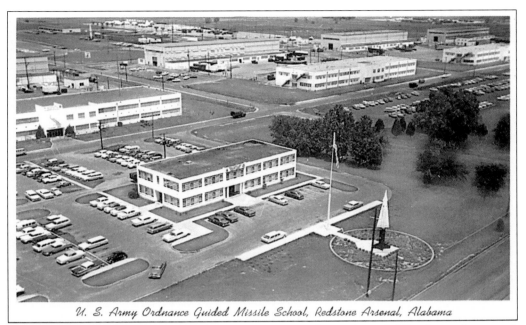

U. S. Army Ordnance Guided Missile School, Redstone Arsenal, Alabama

These are two views of the many buildings located on Redstone Arsenal. The above photograph is of the U.S. Army Ordnance Guided Missile School; the image below is of the U.S. Army Ordnance Command Headquarters.

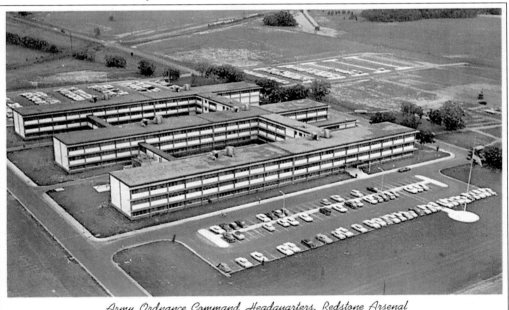

Army Ordnance Command Headquarters, Redstone Arsenal

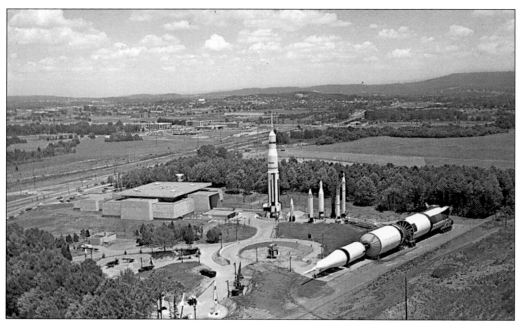

These views are of the United States Space and Rocket Center as it looked upon opening in the early 1970s. Located off of Interstate 565 and Sparkman Drive, the United States Space and Rocket Center is home to the world's largest collection of space hardware and exhibits, including two Saturn V rockets (one unused original and one mock-up) and the space shuttle Endeavor (a full scale mock up used for testing).

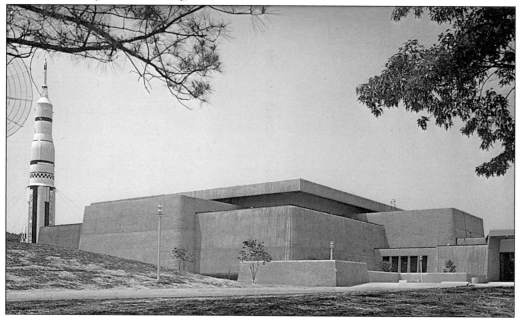

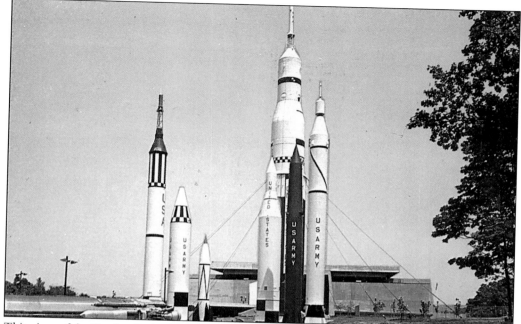

This view of the Rocket Park of the U.S. Space and Rocket Center shows some of the rockets and space vehicles on display. From left to right are the Mercury/Atlas, Mercury/Redstone, Jupiter, V-2, Juno II, Saturn I, Redstone, and Jupiter C missiles.

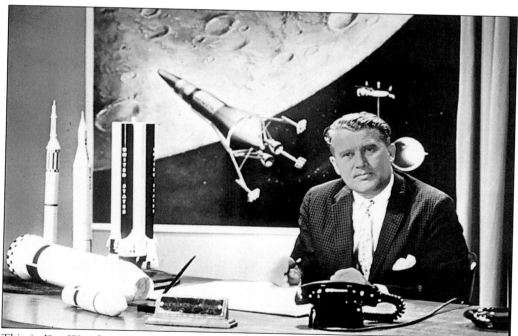

This is Dr. Wernher Von Braun, director of the NASA–Marshall Space Flight Center, with rocket models and hardware at the Huntsville, Alabama Space Installation. Dr. Von Braun is known to most as the father of the U.S. space program.

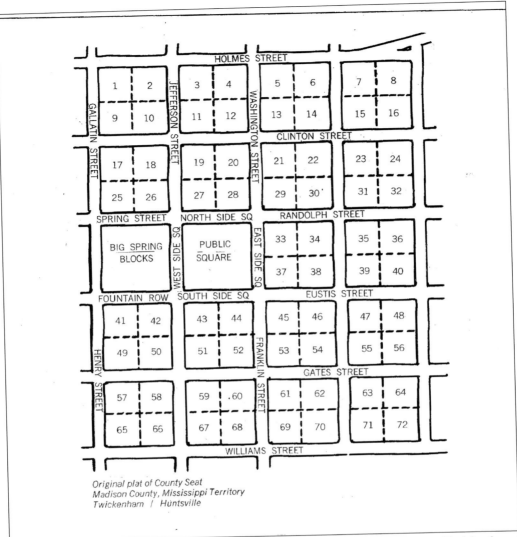

Original plat of County Seat
Madison County, Mississippi Territory
Twickenham / Huntsville

Shown here is the original plat of county seat Madison County, Mississippi Territory, Twickenham/ Huntsville. By territorial statute on December 23, 1809, a commission was appointed and vested with the authority to choose a permanent county seat for Madison County. The act further provided that a majority of this group could "procure by purchase or otherwise" not less than 30 and no more than 100 acres of land to be laid off in half-acre lots with the exception of a 3-acre plot that was to be reserved for public buildings. All lots were to be sold at public auction on 12-months credit, and the proceeds that arose after the land was purchased were to be applied by the commissioners toward defraying the expenses of erecting public buildings for Madison County.

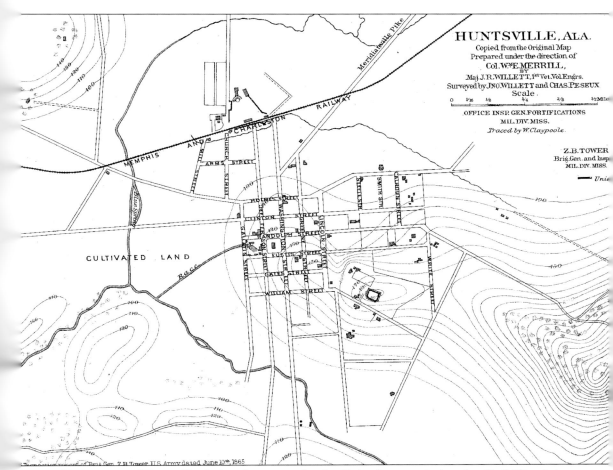

This is a map of Huntsville during the occupation by Federal troops during the Civil War; it is dated June 10, 1865. The original layout of the town is shown along with other newer roads and the Memphis and Charleston Railway that reached Huntsville in 1856. Union fortifications were located at the railroad depot and Echols Hill.

125

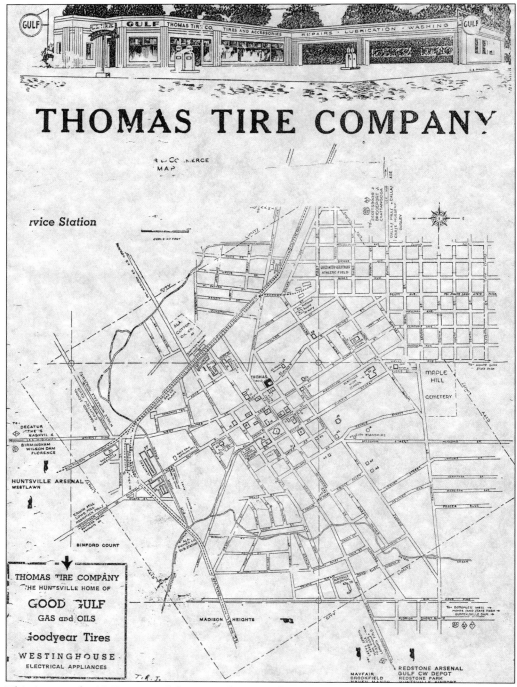

This is an early 1940s map of the city of Huntsville published by the chamber of commerce. Like the two previous maps, the original town layout is very prevalent, but the city limits have been substantially extended.

BIBLIOGRAPHY

Historic Huntsville Quarterly, a publication of the Historic Huntsville Foundation, Inc. Vol. I, No.1, Jan.–March 1975 through Vol. XXV, Nos. 3 & 4, Fall/Winter 1999.

Sesquicentennial Commemorative Album, Huntsville, Alabama, August and September 1955.

Dooling, Dave and Sharon. *Huntsville, A Pictorial History*. The Donning Company/Publishers, 1980.

Huntsville City Directories.

The Huntsville Parker, Vol. 8, No. 1, Huntsville: Huntsville Manufacturing Company, September 1955.

Madison County Commission. Dedication, Madison County Courthouse 1967 A.D.

Stephens, Elise Hopkins for the Historic Huntsville Foundation, Inc. *Photographic Memories: A Scrapbook of Huntsville & Madison County, Alabama*, 1991.

American Association of University Women. *Glimpses into Antebellum Homes of Huntsville and Madison County, Alabama*, 1992.

ACKNOWLEDGMENTS

The selection of cards used in this book came from a pool of more than 500 postcards of Huntsville. Although I have my own collection of local postcards, it would not have been possible to assemble the collection shown in this book without the generous assistance of fellow collectors and the local public library. In the case of borrowed postcards, an acknowledgment follows the captions for these cards.

In addition I wish to extend a special word of thanks to them here, to George and Peg Heeschen (pp. 9, 10, 12, 18, 19, 26, 50, 51, 58 top, 72 top, and 93 bottom) and Charles Cataldo Jr. (pp. 45 top, 63 top, 70, 71, 78 bottom, and 105 top) for allowing me to use some of their very beautiful and difficult-to-obtain cards from their collections.

Thanks go to Raneé Pruitt, archivist, the Heritage Room of the Huntsville-Madison County Public Library (pp. 35 bottom, 60 bottom, 61 top, 83 bottom, 92, 111 bottom, and 116 top), for assisting me in copying some of the wonderful cards from the library's permanent collection.